An Introduction to
Rembrandt

Other works by Kenneth Clark

The Gothic Revival

Landscape into Art

Leonardo da Vinci

Leonardo da Vinci Drawings at Windsor Castle

Piero della Francesca

The Nude

Looking at Pictures

Ruskin Today

Rembrandt and the Italian Renaissance

Civilisation

The Romantic Rebellion

Another Part of the Wood

The Other Half

An Introduction to

Rembrandt

Kenneth Clark

Icon Editions
Harper & Row, Publishers
New York, Hagerstown, San Francisco, London

ISBN: 0-06-430860-X
LIBRARY OF CONGRESS CATALOG CARD NUMBER: 77-3745

78 79 80 81 10 9 8 7 6 5 4 3 2

Contents

To John and Anya

Introduction

Not another book on Rembrandt! How can I excuse myself? It is simply the overflow of an admiration for his art, and a love for his character, which is revealed in all his graphic art, that first occupied my mind when I was a child, and is still growing and expanding. I copied his drawings and etchings when I went to school, and have been lecturing about him for almost fifty years. Mr Berenson, when I gave him my book about Piero della Francesca, paid me a left-handed compliment. 'Rembrandt', he said, 'is the only artist you really understand'; and perhaps the honour that has touched me the most deeply in my life is that in 1969 the Dutch invited me to give the Commemorative Speech in the Rijksmuseum on the three-hundredth anniversary of Rembrandt's death.

All this emboldened me to publish a book called *Rembrandt and the Italian Renaissance*, which was based on the Wrightsman Lectures for 1964. It was too much of a thesis for the general reader and, since Rembrandt scholarship is very much the monopoly of the Dutch, and is most of it written in the Dutch language, which I read with difficulty, it was rather coolly received by Rembrandt scholars. Nevertheless, I believe that it contains a few paragraphs of description and criticism that are worth preserving, and some of them reappear in the pages that follow.

The present book is based on a series of television programmes which I made for the Ashwood Trust. This Trust was established in order to encourage interest in the arts in schools and universities. I have therefore avoided scholarly discussions, but this does not mean that I am unaware of them.

The book is illustrated entirely in black and white. Rembrandt's colour is often beautiful and significant, but it is exceptionally difficult to reproduce satisfactorily. Moreover, the aim of my book is to examine his work in the light of his feelings, his thoughts and his beliefs, and these are expressed most freely in his etchings and drawings.

I must record my warmest thanks to Mr Charles B. Wrightsman, and to the Institute of Fine Art in New York University, who have generously allowed me to include in Chapters 2, 3 and 4 a few quotations from my earlier book. I am particularly indebted to two Dutch scholars, Professor Seymour Slive, and Dr Bob Haak. The latter

is Director of the Historical Museum of Amsterdam, and his approach is that of the archivist, which is diametrically opposite to my own. He has made accessible several documents hitherto difficult to find, particularly those on the subject of Geertghe Dircx. I would also like to express my thanks to Robert McNab, who has helped me collect the relevant photographs, and to the Royal Institution, which has allowed me to use the substance of a lecture on Rembrandt's Self-Portraits, which I originally gave under their auspices.

K.C.

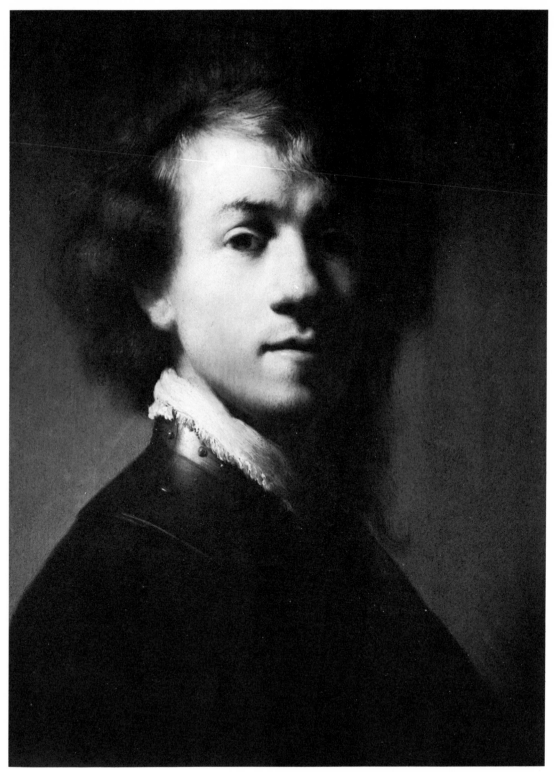

1 *Self-portrait. Mauritshuis, The Hague*

The Self-portraits *1*

I suppose that everyone who cares for painting would agree that Rembrandt was one of the greatest artists who have ever lived; and even those who don't care for painting are touched by some of his works – almost personally – in a way that they are by no other artist. Because, apart from his immense gifts as a pure painter and an illustrator, he digs down to the roots of life; and he seems to open his heart to us. We have the feeling that he is keeping nothing back.

To begin with, his own character – and, since this plays so important a part in his work, an introduction to Rembrandt may well begin by seeing how he looked at himself from youth to old age. He is, with the possible exception of Van Gogh, the only artist who has made the self-portrait a major means of artistic expression; and he is absolutely the only one who has turned self-portraiture into an autobiography. To follow his exploration of his own face is an experience like reading the works of the great Russian novelists.

He was born in Leyden in 1606, the son of a miller. This does not mean, as romantic historians used to suppose, that he was poor and illiterate. On the contrary, his father seems to have been quite comfortably off, and sent him to the University, where he matriculated, at the early age of fifteen. I mention this because Rembrandt's sympathy with humble people has led to the illusion that he was uneducated and unintellectual, whereas we can see, if we analyse his pictures, that he was widely read and has a powerful mind.

Still, one must admit that the young man whose first self-portrait is now in the gallery at Cassel [2] doesn't look like a highbrow. He has covered his wide brow with a mass of rather unconvincing curls, and has made his lips thicker and more boorishly sensual than we ever see them again. The study of Rembrandt's early self-portraits is a study of self-discovery. The Cassel portrait depicts the side of his character that I shall speak of in the next chapter – the rebel. But only a few months later he did the beautiful portrait in the Mauritshuis [1], in which he depicts himself as an intelligent, well-dressed young man who was soon to become the most fashionable painter in Amsterdam. As our ancestors used to say 'This young man will go far'.

What was the truth? I think we can see it in a drawing in the British Museum [3] which, from its spontaneity alone, suggests that it is a true

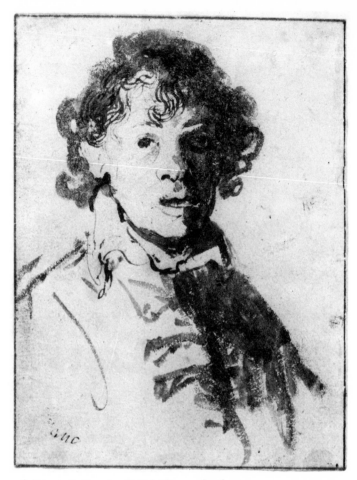

3 *Self-portrait. Drawing. British Museum, London*

2 *Self-portrait. Gemäldegalerie, Cassel*

record, and which, in a remarkable way, unites the two early paintings. The drawing emphasises what was to become the shameless, dominant feature of all Rembrandt's self-portraits, the nose. It is not altogether omitted from the Mauritshuis portrait, although modified in the interests of respectability. In fact it becomes the nub of the whole picture in a self-portrait now in Munich, dated 1629 [6]. In the same year he did a rough, reckless etching [5] in which we see one of his first efforts to grow a moustache. The technique alone convinces us that he has taken a violent short-cut to the truth. There is one other early self-portrait, now in Stockholm; at least I assume that it is early as it has no moustache and Rembrandt does not seem to have

shaved off his moustache after 1630 [4]. This shows us a third person, the serious man, the man who was to spend so much of his life pondering the truths of religion. The nose is still there, but the sensual lips have gone, and the head is dominated by its penetrating eyes. This is the antecedent to the profound portrait of himself etching at a window of 1648 [18].

Why did Rembrandt, who, as a pupil of the Amsterdam painter Lastman, had attempted great dramatic themes, feel the need, at an early date, to make these experiments in self-examination? He does not look the introspective type, although tough young men are often deceptive, and if they happen to be young men of genius there is the overflow of vital egotism to be reckoned with. More probably he was simply in need of a model who would be available when his father was working in the mill, his mother at church and his sister

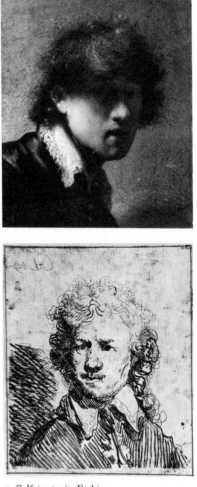

6 *Self-portrait. Alte Pinakothek, Munich*

5 *Self-portrait. Etching*

4 *Self-portrait. National Museum, Stockholm*

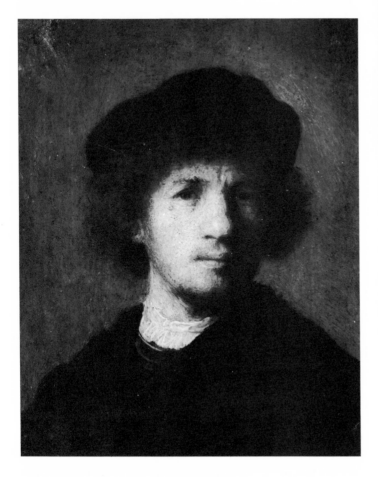

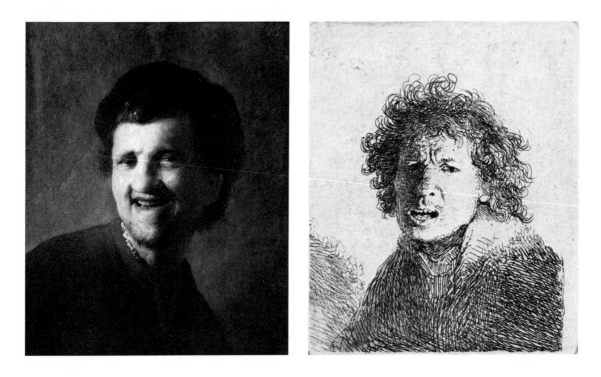

in the kitchen. And, as all young artists know, one's own reflection in a mirror is a model that can be treated with greater freedom than is possible with friends and relations. That was what the young Rembrandt wanted. The earliest critical notice of Rembrandt, by the very intelligent Dutch connoisseur Constantin Huyghens, compares him with his friend Jan Lievens. 'Lievens', says Huyghens, 'was superior in grandeur of invention, but Rembrandt excelled in *affectum vivacitate*', which I suppose could be translated as vivacity of emotional expression. All his life Rembrandt's deepest ambition was to give visible form to human feelings; and this at first meant simply making faces. He portrayed himself because he could make the faces he wanted, and could study the familiar structure of his own head distorted by anger, laughter or indignation. In about 1630 he painted a picture of himself laughing [7], which is as vivid as a Frans Hals, and entirely confirms Huyghens's judgment. But it is chiefly from a series of small etchings that we know these face-making exercises. They include laughter and amazement, but the majority are scowling or snarling [8 and 9]. This present age is not the first in history in which young men have been angry and contemptuous of polite society.

In the year after this etching the rebellious young man from Leyden decided to seek his fortune in Amsterdam. Since it is usually young men of talent who are angry, it is the angry young men who are successful, and this can be a source of embarrassment to them.

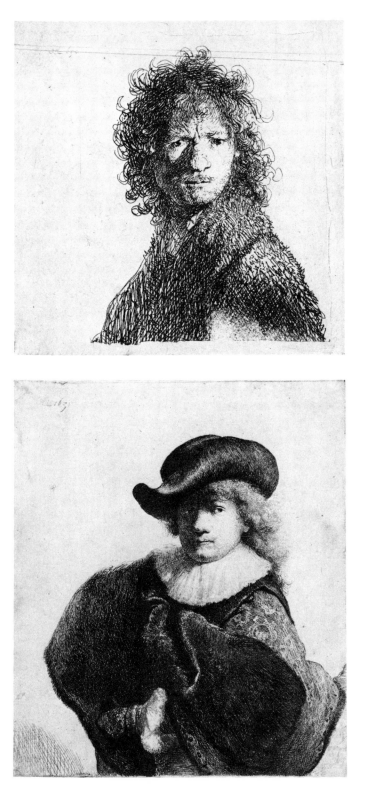

9 *Self-portrait. Etching*

10 *Self-portrait, 1631. Etching*

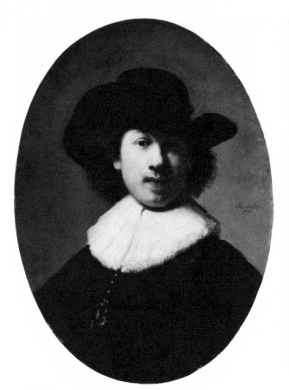

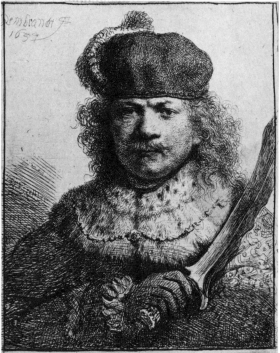

11 *Self-portrait.*
Burrell Collection,
Glasgow

12 *Self-portrait,*
1634. Etching

But it did not worry Rembrandt, and in 1631, the year after the snarling portrait, he did an etching of himself, smartly dressed with cocked hat and cloak [10] and clearly well pleased with the results of his new-found prosperity. It is the first of the 'show-off' self-portraits that continued till 1639. He had gone to live in the house of a successful art-dealer named Hendrik van Ulenborch, who acted as his agent and also gave him the chance of seeing all the old masters which passed through the Amsterdam art market. He did his best to conform, and painted one self-portrait [11] in which he has taken on the protective colouring of the class he had adopted – or which had adopted him. Well, there is no doubt that this *is* a self-portrait. But a good many of the 'show-off' portraits of the next five years leave me guessing. Is the famous head and shoulders of a man in Berlin really a self-portrait? There is just a hint of the nose, so it may be a much romanticised image. But what about the etching of 1634 [12]? Surely this foxy cosmopolitan never was the hard-worked boy from Leyden! Yet one never knows.

By 1632 Rembrandt was a success, and as a result he married the cousin of his landlord, Saskia van Ulenborch, a young lady of good family, ample dowry and quite adequate charm. To maintain his new way of life he accepted commissions from the prudent, cheese-faced merchants of Amsterdam; but they bored him; their black clothes, then

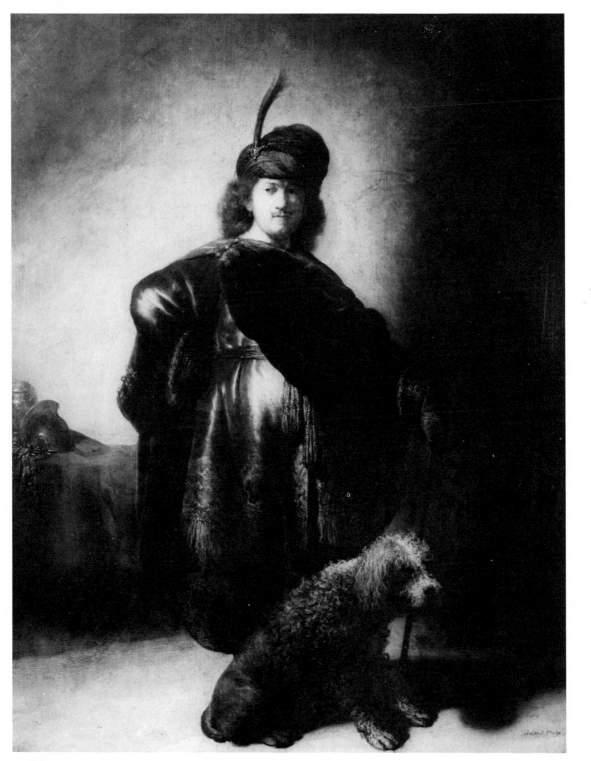

13 *Self-portrait, 1631, Musée du Petit Palais, Paris*

just come into fashion, and stiff white linen offered no means of expressing in paint his sense of the richness of life. And in several pictures he protests against their sobriety both of dress and behaviour. In these years he is like a child finding a trunk of old clothes in the attic, and pulling out of it all the richest material it contains. He dressed up Saskia in these improbable garments, and painted her as Flora or Persephone. And he put on fancy dress himself; in fact he had been doing so ever since he had come to Amsterdam, as we can see from a picture in the Petit Palais, Paris dated 1631 [13]. Incidentally, this picture shows that Rembrandt was a small man. To those who know Charles I only from Van Dyck, it is a shock to see from Pot's picture in the Royal Collection that he was extremely short. From the historian's point of view it is satisfactory when the flattering images of great portrait-painters are accompanied by the factual directness of a mediocrity.

I have implied that Rembrandt dressed himself up chiefly because he liked painting rich fabrics. But was this the real reason? Was he moved solely by the desire to squeeze more colour on to his palette? This etching of 1634 [12], by the very fact that it is an etching, suggests that he had another motive. Nose or no nose, Rembrandt felt in his character something kingly. It is often said that great men are humble, and in the deepest sense this was true of Rembrandt. But however humble they may be before God, great men are usually well aware of their greatness, and with Rembrandt this consciousness expressed itself for many years in his love of fur caps, gold chains and other splendid accoutrements. Sometimes, as I have said, he is simply romancing. But the etching of 1634 is one of the first of the self-portraits in which Rembrandt has taken pains to achieve a truthful likeness; that is to say, it fits in with those later pictures in which his sole aim has obviously been to record his features in the most straightforward manner. Without wishing to insist on a psychological explanation, one cannot help wondering if the princely accoutrements did not, so to say, excuse Rembrandt from romanticising his own face, and left him to portray it exactly as it was.

In studying Rembrandt one soon gives up trying to relate the self-portraits to the known facts of his life. Or should one rather say that his painting was his life; and, as with Shakespeare, a credible biography must be deduced from his work, and not from a few haphazard documents? On the basis of one or two early portraits of Saskia it is sometimes assumed that his marriage was idyllically happy. Other evidence, in particular his obsession with the story of Samson, suggests that Rembrandt may well have felt, like so many other artists, that his rise into respectable bourgeois society had been a mistake, and when Saskia died, in 1642, no shadow of the event is to be found in his self-portraits, which at this date are singularly smug.

Up to now I have spoken about Rembrandt's self-portraits in purely psychological terms. But, of course, a portrait – and in particular a self-portrait – presents a problem of pictorial construction. The painter must invent a pose which shall be both natural and commanding, stable and dynamic. The simplest poses, like the simplest tunes, are almost miraculous discoveries, as one can see from the way in which the *Mona Lisa* and Titian's *Man with a Glove* continued, for centuries after they were painted, to provide painters with a convenient motive. Professional portrait-painters have been driven to elaborate subterfuges, so that Reynolds arranged his ladies in the attitudes of Michelangelo's Sibyls, and Ingres would choose a sitter only if she could fall into the pose of Graeco-Roman sculpture.

Rembrandt's early self-portraits are often little more than faces, although even in these the turn of the head and its relation to the direction of the eyes adds greatly to the tense, personal rapport with the sitter. But as his professional skill and ambition increased Rembrandt sought to vary and enlarge the range of his poses; and in one instance we have a fairly complete record of how this was done.

In the 1630s the beautiful portrait by Titian of a man with a quilted sleeve was in a collection in Amsterdam. It was traditionally thought to represent Ariosto, but I agree with the author of the new National Gallery catalogue in thinking that it has the character of a self-portrait. The structure of the face is not at all impossible for the youngish Titian. At the same time another great Renaissance portrait was for sale in Amsterdam, Raphael's *Castiglione*. We may assume that Rembrandt had seen the Titian, as he saw all the old masters which passed through the Amsterdam sale rooms. We *know* that he saw the *Castiglione* because he made a scribble of it – one might almost say caricature of it – at an auction in 1639 and made a note of how much it fetched [15]. Here he has turned the head more to the left, given the hat a jauntier angle, and suggested that the left hand and arm were on a ledge, instead of clasping the right hand. The results of these two experiences are: first the etching of 1639, in which he had used the billowing silken sleeve of the Titian, and has produced the image of himself which proved most acceptable to the world in prosperous times [16]; and a year later he painted the portrait in the National Gallery, London [14], in which he has thought more of the Raphael, even imitating Castiglione's costume, but making the whole effect less still and self-contained.

The more closely one looks at Rembrandt's work, the more one realises how intelligently he studied the great Italians of the Renaissance, especially Raphael. Through this study he learnt to give his poses a balance and finality much beyond the baroque conventions of his youth, and in the great self-portraits of the 1650s one finds concealed under an appearance of naturalness an absolute mastery of pictorial construction.

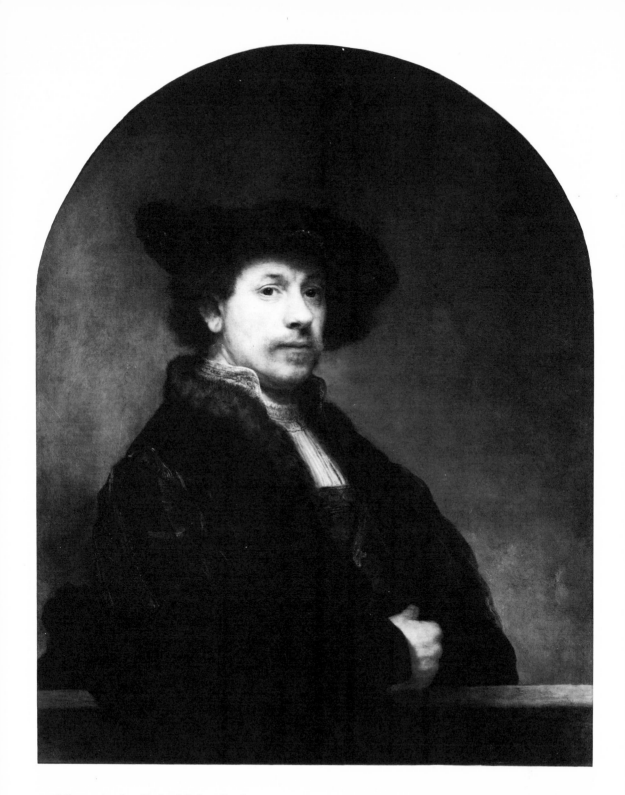

14 *Self-portrait, 1640. National Gallery, London*

In the National Gallery portrait Rembrandt looks well pleased with himself, and throughout most of the 1640s this expression of bland self-satisfaction is maintained – and even increased – but ended in about 1648 when he began to have trouble with Titus's nurse, named Geertghe Dircx, who finally brought a breach of promise suit against him (see page 86). These smug, self-satisfied self-portraits are indeed the most mysterious of all Rembrandt's works, and I can offer no explanation of them. They do not fit in with our present-day feeling of his character. But we must remember that they were once amongst his most admired works. Then in 1648 he makes a more serious effort at self-examination in the wonderful etching of himself drawing at a window [18]. If the etching with the velvet sleeve was an image for pre-1914, this is an image for today. For the first time for almost twenty years he discards his fine clothes, gold

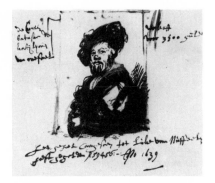

15 *Drawing of Raphael's portrait of Castiglione. Albertina, Vienna*

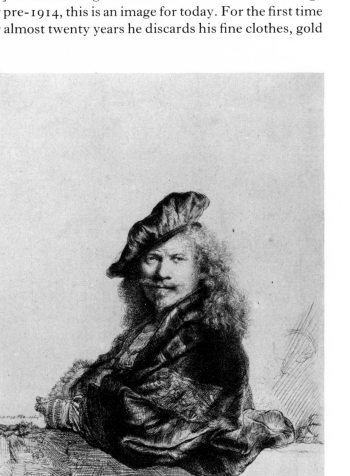

16 *Self-portrait, 1639. Etching*

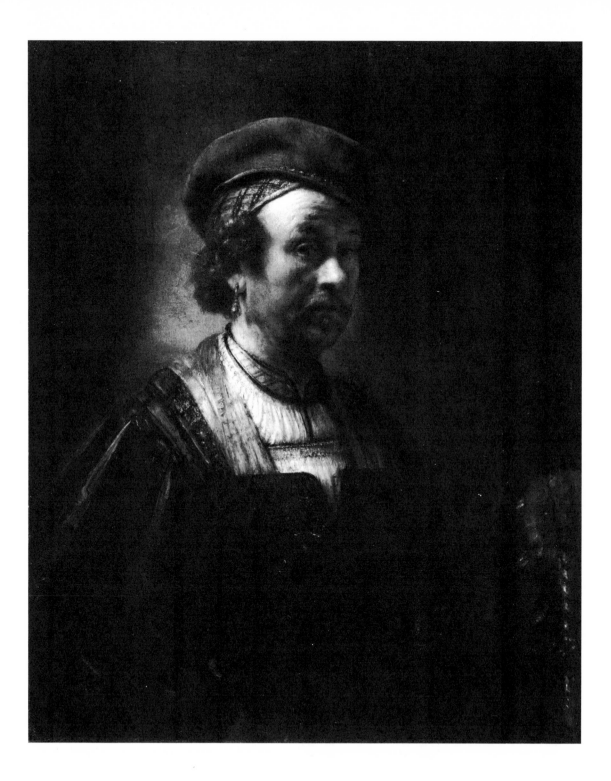

17 *Self-portrait. National Gallery of Art, Washington*

chains and velvet caps, and shows himself in working dress; and for the first time he scrutinises himself with a sad and thoughtful eye. In abandoning his romantic disguise he has also abandoned all romantic illusions about his face, and although he was to dress himself up again, he never again shows us the plump, confident visage of the 1640s.

It is an indication of how little we know about Rembrandt's life that we have no idea what happened to him in the late 1640s to change his attitude from self-satisfaction to anxious self-questioning. In painting, this change is shown most decisively in a picture in the National Gallery of Art in Washington, formerly in the Widener Collection [17] dated (but the signature is false) 1650. The absolute truthfulness of the etching has turned into a slightly self-conscious feeling of melancholy. Perhaps it is this self-consciousness, as well as some stylistic difficulties, that have led a leading Rembrandt expert, Dr Gerson, to doubt the authenticity of this beautiful work. But it does not fit in with the style of any of Rembrandt's pupils at the time, and so if it is not authentic it would have to be the work of a forger. I find this hard to believe, and so, for the time being, would leave it where it has always been, a decisive turning-point in Rembrandt's attitude towards his own face.

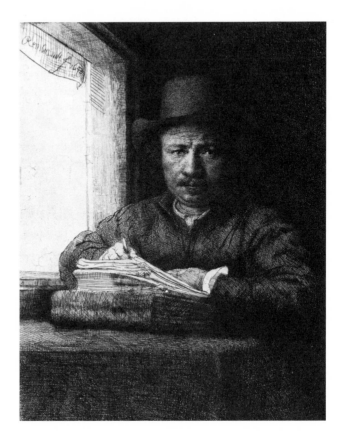

18 *Self-portrait, 1648. Etching*

23

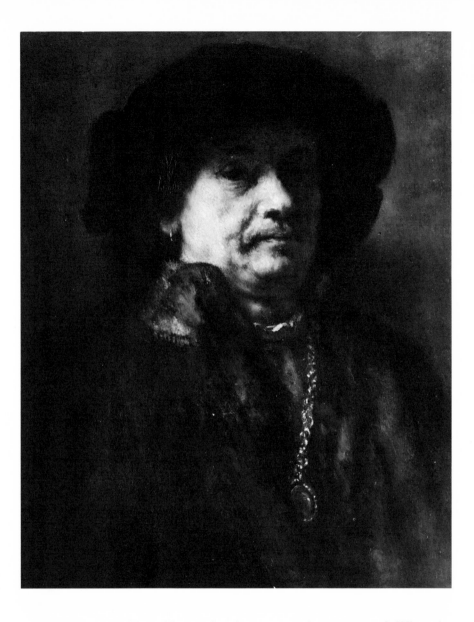

19 *Self-portrait,
1655.
Kunsthistorisches
Museum, Vienna*

How far was this self-examination a conscious process? When he
painted the head in the Vienna Gallery [19], to take a typical example,
how far did he ask himself questions about the image in the mirror?

Portrait-painters sometimes tell me that when confronted with a
sitter they do not think of his character at all, but look at his face like a
still-life which never keeps quite still enough, and concentrate on the
difficulty of realising its structure. One eminent portrait-painter said he
wished his sitters could be hung upside-down by the leg, like a dead
hare. No doubt the portrait-painter is much more deeply absorbed in
the application of paint than the layman imagines. But with Rembrandt

20 *Self-portrait. Drawing. Metropolitan Museum of Art, The Robert Lehman Collection, 1975, New York*

there seems to have grown up an almost perfect balance between a pictorial and a psychological approach. I suppose that he first of all caught sight of himself in a certain mood – the chance encounter in the unexpected mirror – and felt impelled to record it. This supposition is confirmed by his portrait drawings, two of which date from this period. One, in the Lehman Collection [20], shows that he has suddenly felt conscious of how sad and ravaged his face has become, perhaps for the first time; because I think the drawing must date from 1650–51, a year in which he seems to have grown relatively thin. And here in a much later drawing [21] is the exact opposite, when he has caught sight of himself in working dress, with the same hard-brimmed hat that he is wearing in the etching of 1648, and gladly recorded this vision of a stocky, firmly planted, keen-eyed painter. In doing so he has made his head unrecognisable; indeed one must take it on trust that this drawing really

21 *Self-portrait. Drawing. Rembrandt-huis Museum, Amsterdam*

represents Rembrandt, and is not simply his ideal of a master craftsman.

In the earlier portraits one might say that he plays a part. In the later portraits he discovers characters, and, as with the creations of the great novelists, these are usually fragments of the author's own character. Rembrandt's face continues to show variations, even after he has ceased to dress up and put on an act; but they are all faces of the same man. The mood varies greatly, tragic, resigned, humoristic, introvert, extrovert, but it is the same face.

What, if we may presume to guess, was the process? The shock of recognising a 'character', revealed in the pouches and wrinkles of his own face, was the first stimulus of the portrait. But as he prepared his palette he would pass into another state, and by the time his brush was approaching the canvas he would be thinking only of how to render the exact shape of each wrinkle, the exact colour of each pouch.

Then, as he stood back to contemplate the result, he could see how far from heroic this pictorial obsession had made him. At this point most of us would be tempted to let the two processes overlap: to modify very slightly that purplish red of the left eyelid. But not Rembrandt. The two strongest impulses in his character combined to prevent it. He was driven on by a passion to set down every shape, area, tone and colour exactly as he saw it; and he had concluded that human beings must be accepted exactly as they are. That is how we find them in the Bible – without extenuation or disguise. And if Rembrandt was to approach all his sitters in this way, he must begin with the sitter he knew best.

In another picture in Vienna dated 1652 [22] he still allows himself a certain amount of pictorial pleasure; he is conscious that he is at the height of his powers, and his sense of mastery to some extent moderates his treatment of himself. But four years later, in 1656, he feels that he must get to the root of the matter. He must go on and on, putting in more and more, without thinking of the consequence pictorially, determined only to map out the last revealing wrinkle. The result is a picture usually known as the Ellesmere portrait that hangs in the National Gallery of Scotland [23] – a disturbing work from several points of view; disturbing because it worries us that any face should be looked at so relentlessly, and disturbing because by admitting so much evidence this portrait, in black and white, seems to come very close to the unselective eye of the camera; and the works of art of which the Ellesmere portrait reminds me are the photographs of old men by Mrs Cameron.

I have said that it is dangerous to relate Rembrandt's self-portraits to the known facts of his life. It happens that in 1656, the year of the Ellesmere picture, Rembrandt was finally declared bankrupt. To be strictly accurate, he obtained a *cessio bonorum* by which he avoided legal bankruptcy. His finances had been in a muddle for some time and one

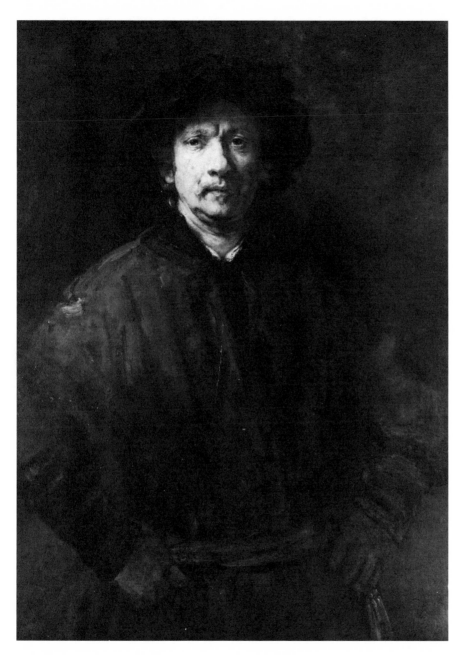

could easily say that this culminating disaster led him to take stock of
himself – and the result was the picture on page 25 [20]. That would be
the effective presentation of journalism; but as a matter of fact we know
nothing at all about Rembrandt's feelings at the time.

After his bankruptcy he continued to live in his big house for another
eight years, and under these depressing conditions painted the calmest

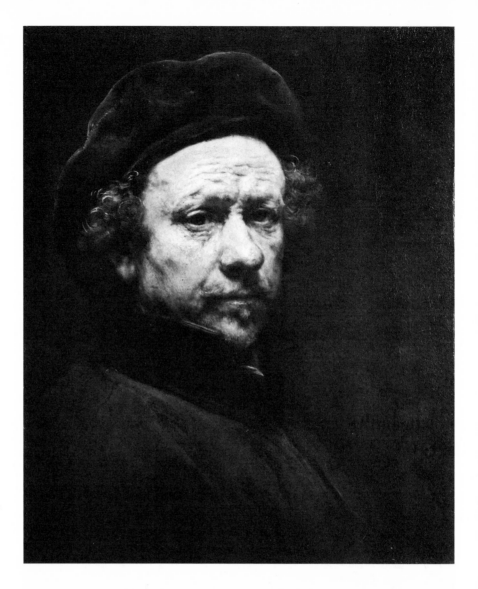

23 *Self-portrait,*
1657. Collection, Duke
of Sutherland, on loan
to the National
Gallery of Scotland,
Edinburgh

and grandest of all his portraits – the superb picture in the Frick
Collection – painted in 1658, the very year in which he was forced to sell
his collection [24]. He is the embodiment of philosophic calm. The
inner conviction that I mentioned earlier, that there was about himself
something kingly, once more controls his vision. But by now he is the
philosopher-king, and perhaps his conversations with both Christian
and Jewish theologians have given him a feeling of priesthood. This
regal detachment is accompanied by an extraordinary breadth of
technical means. After the descriptive analysis of the Ellesmere portrait,
this marvellous head is the climax of a grandiose pictorial construction.

In the next year the philosopher-king has vanished, and the image of

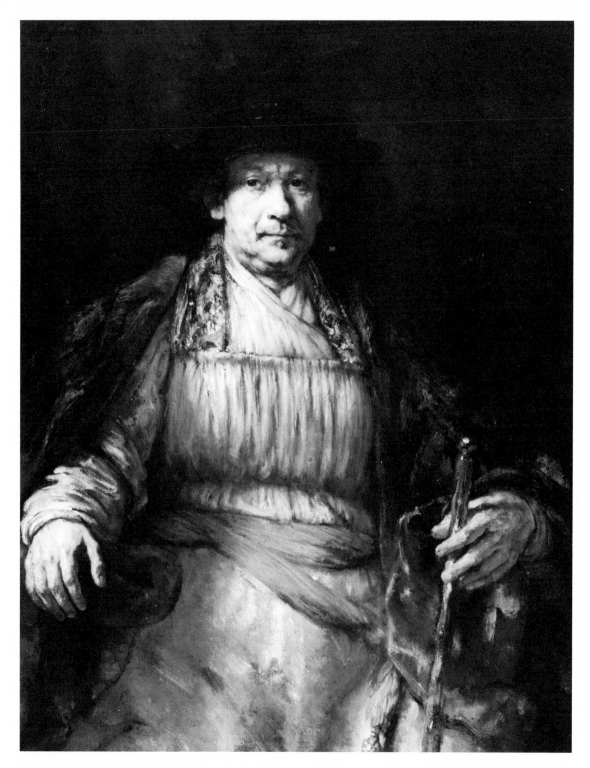

24 *Self-portrait, 1658. Frick Collection, New York*

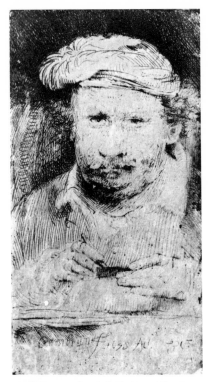

25 *Self-portrait, 1658. Etching. Albertina, Vienna*

anxiety has returned. We find it first in the picture in the Mellon Collection at Washington [26], which has some of the relentless scrutiny of the Ellesmere portrait but with, I feel, an added suggestion of disease.

As none of Rembrandt's personal letters has survived – only letters to his patron Huyghens – we do not know how far he was concerned with that topic which occupies so much space in the letters and diaries of most great men – his health. But we may assume that in middle age he had his fair share of illness, and the self-portraits suggest that this took place in 1659. He seems to have been well enough in 1658; apart from the philosopher-king, which may be idealised, his own face is the subject of a small etching – almost his last [25] – which looks like a completely straightforward record of his appearance, and which shows him well filled out and solid looking.

In the Mellon picture he is hollow-eyed and apprehensive. Personally I think that the small sketch of his head in Aix-en-Provence was painted during this illness, perhaps at the end of 1659. It is usually thought to be later, but he was never again so haggard and thin. The emphasis and the violence of handling suggest a nervous exacerbation which we find practically nowhere else in his work. It is the picture of a sick man.

Then, as he recovers his balance, comes the portrait in the Louvre dated 1660 [27]. We see that his illness has left him battered and changed. He has become the *old* Rembrandt – in fact he was only fifty-four. This is one of Rembrandt's most moving works, in which he seems to have recognised all that was tragic in human life, and set it down with humility and resignation. He does not glory in suffering; he simply accepts it, or rather the visible evidence of it; and in so doing he achieves a spiritual dignity which is denied to the prosperous and the proud, however great their gifts. This is a Christian portrait, in the sense that under no other system of belief could sinful and suffering man have reached such heights. Not that Rembrandt gave himself any airs as a saint or prophet. On the contrary, he viewed his Christian humility with a certain amount of humorous disillusion. The impulse to represent himself as a tramp, which appears in the etching of 1630, still moved him in 1660; and appears in a portrait in Melbourne. Waiting for Godot! When one considers that this portrait is

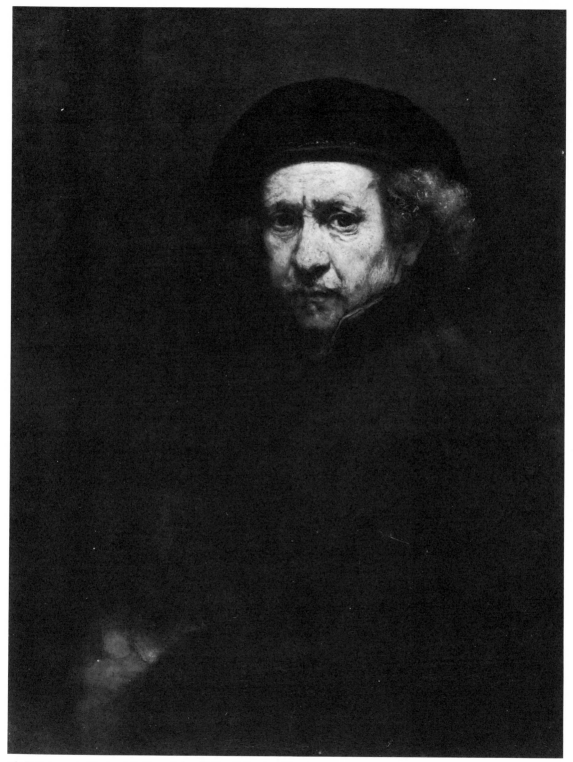

26 *Self-portrait. National Gallery of Art, Mellon Collection, Washington*

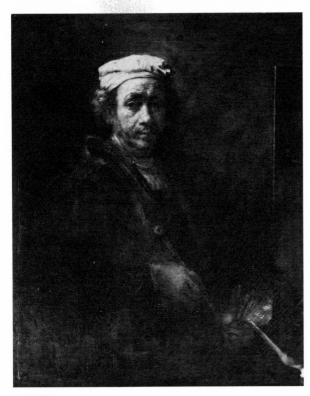

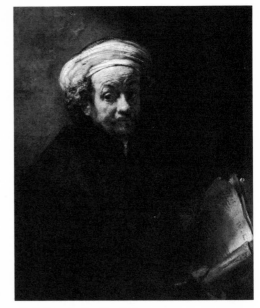

28 *Self-portrait, 1661. Rijksmuseum, Amsterdam*

27 *Self-portrait, 1660. Louvre, Paris*

separated by only two years from the philosopher-king of the Frick Collection, one realises the extent to which Rembrandt is still using his face to create characters.

Like all the great characters of fiction they are extremely complex, and any attempt to interpret them is liable to impoverish them.

How, for example, should one describe the expression in Rembrandt's face in the picture of himself as St Paul [28] painted the year after the Louvre portrait, now in the Rijksmuseum? It is one of the most penetrating and personal of his works; one cannot accept it with detachment as one does, say, a portrait by Velazquez. One is inevitably engaged, drawn in. And what does one find? Sadness of course: humour of course. But beyond that, something mysterious, some memory of a journey into the world of the imagination where we cannot accompany him. I said earlier that Rembrandt's imagination was combined with a powerful mind. This portrait reminds me of one of the great faces of our century, the face of Albert Einstein.

In this year, 1661, Rembrandt's beloved companion, Hendrickje Stoffels, made her Will and died; but as usual nothing of this is revealed in his portraits. All we can see is that in the following years he put on weight.

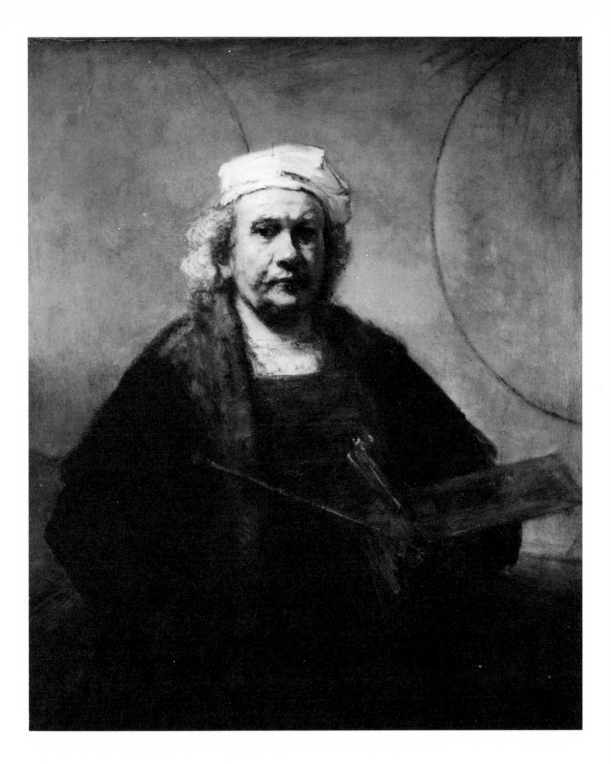

29 *Self-portrait. Iveagh Bequest. Kenwood, London*

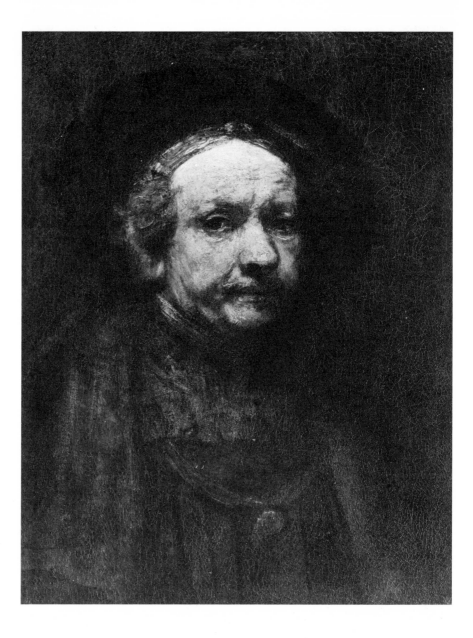

The magnificent portrait at Kenwood [29] shows a solid, commanding character. The head is modelled more broadly, almost without wrinkles, and there is no feeling of introspection. He is not looking for a character, he is simply painting, and his mastery of the medium has made him feel detached and at ease.

This mastery was still recognised abroad, even after he had gone out of fashion in Holland. The Grand Duke Cosimo III de' Medici made a point of visiting him when he was in Amsterdam in 1667, and the Cardinal Leopold de' Medici commissioned him to paint a picture for

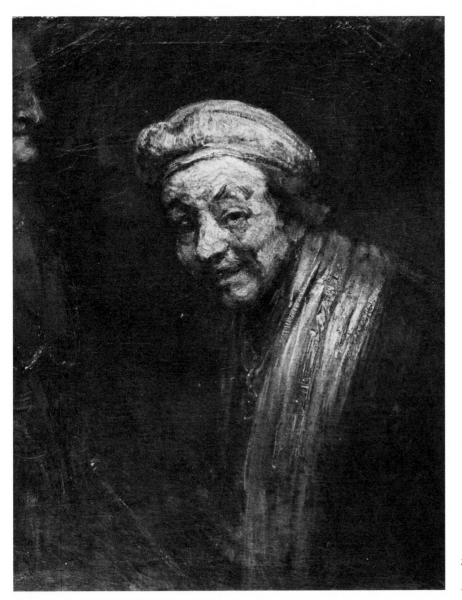

his famous collection of self-portraits. It is still in the Uffizi [30]. For the last time Rembrandt has dressed himself up in his fur stole and chain, and his tired old face has the defensive look that decent people adopt on official occasions.

In Cologne, painted at almost the same time, is his *un*official portrait [31]. He is laughing and, as so often with Rembrandt, we are dumbfounded. Hendrickje was dead; Titus had married and left him. He was in the worst money trouble of his life, and actually had to break open his daughter Cornelia's money-box in order to pay for a meal.

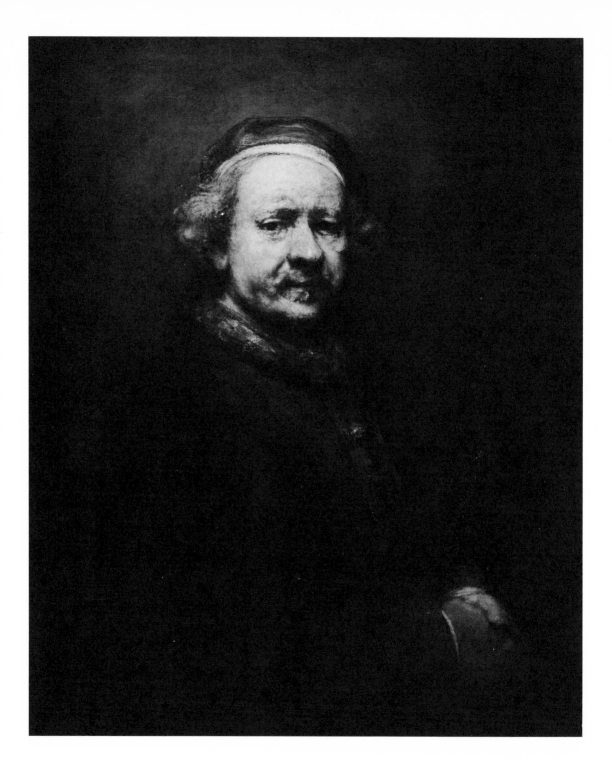

32 *Self-portrait, 1669. National Gallery, London*

Rembrandt had no reason to laugh. Of course one could compose a little piece of literature on the subject of tragic laughter; but I doubt if this would really interpret his intention. I am more inclined to think that he looked back, as elderly artists often do, at some of his early successes, and thought he would see if he could still achieve that vivacity of expression which had first brought him fame. Perhaps he even had in mind the picture on page 14, and the tragic, mysterious quality of the later laugh was almost unconscious, although not the less moving on that account.

Two more self-portraits remain. One of them [32] is the familiar picture in the National Gallery, London, which has now revealed a date, 1669 – the year of his death. It lacks the spectral, unearthly character of the portrait in the Louvre, but the expression is equally enigmatic. Certainly there is no open admission of tragedy and defeat. One can almost say that the acceptance of life, which was tragic in the Louvre picture, has now become humorous; and one can understand why a contemporary biographer described him as an 'umorista di prima classe'. This is the Rembrandt who used to say to visitors who wanted to peer into his pictures as if they were the polished bibelots of Dou or Netscher 'Don't go too close, the smell of the paint will bother you'.

This is one of his most amiable likenesses, and I wish we could leave him with this picture in mind; but we can't; because the small head and shoulders now in The Hague [33], also dated 1669, must, I think, be a little later, and, touching though it is, we are conscious of a setback. The features that we have come to know so well are still there – the nose, the pouches, the crumpled forehead; but they have somehow lost their vital relationship to his character. The face is chubby and formless, and we realise how much the intensity of all Rembrandt's self-portraits is due to his pictorial grasp of the structure of the head. Above all, the eyes have gone dead; and if we look back at any one of his portraits, even those which do not attempt depth of characterisation, we see that the eyes are always marvellously intelligent and alive.

I suppose we must rid ourselves of the sentimental notion that great artists never grow tired, but go on improving to the last, and accept the fact that Rembrandt, like Shakespeare and Turner, finally lost that creative vitality of which the young student of Leyden University seemed to have such an overpowering store.

Vitality, an insatiable appetite for life, that surely is the chief characteristic of all the greatest novels and of all the autobiographies we still care to read; and when we compare Rembrandt with some other portrait-painters – with his most famous contemporaries, Velazquez and Van Dyck – his total immersion in human life seems to give his portraits, particularly his self-portraits, a new dimension.

But with this whole-hearted engagement went an equally great

detachment, the two sides of his character mingling as imperceptibly as the two sides of a spinning disc. This is what makes his self-portraits unique. His appetite for life urged him to gobble up his own image, but his detachment freed him from all the evasions, excuses and self-pity which are the normal human reaction to that clamorous, irrepressible thing – the self.

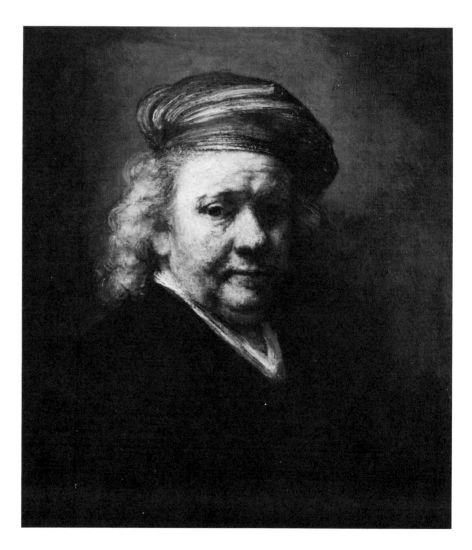

33 *Self-portrait,*
1669. Mauritshuis,
The Hague

The Rebel 2

Looking at Rembrandt's early self-portraits we saw that he was a tough, rebellious young man. In some ways he remained a rebel all his life, and to understand him we must try to find out precisely what he was rebelling against. To begin with, he did not rebel against his family. On the contrary, the most moving of his early works are portraits of his mother. She is represented in early etchings that seem to achieve a delicacy and insight far beyond any of his other works of this time; and in a series of paintings. The best version is in Windsor Castle [34], and was, incidentally, one of the first of his pictures to be bought outside Holland, on behalf of Charles I. Two of the series show her reading the Bible, and there is no doubt that Rembrandt had a stern religious upbringing. He didn't rebel against that, and in one of his earliest drawings, which shows the family seated round a candle with earnest expressions, reading a book, I think it can be assumed that the book was the Bible. He has left us a drawing of his father, now in the Ashmolean, Oxford, done with undoubted sympathy [35]. It is inscribed with his father's name in a contemporary hand – and it shows that many of the pictures of elderly men known as *Rembrandt's father* are of a neighbour who was prepared to act as model. Rembrandt did not lack models because there was never any doubt in the minds of his fellow citizens in Leyden that the young man had an exceptional talent for painting. A visitor from Utrecht in 1628, when Rembrandt was twenty-two, wrote, 'The Leyden miller's son is greatly praised, but before his time', which in a sense was true, because the very earliest pictures by Rembrandt, done under the influence of the painter Lastman, are not attractive, except to historians, and must have seemed singularly inept to a man from Utrecht, where the local painters like Terbrugghen had achieved an international facility. A picture in Leyden, called *The Justice of Brutus*, shows the young Rembrandt peering out of the background. Otherwise it is completely uninteresting.

The school of Utrecht (in the early 17th century every town in the Netherlands had a school of its own: there was no such thing as Dutch art as a whole) had felt more strongly than anywhere else the spell of the great Italian painter, Caravaggio. Caravaggio was not so much a rebel as a revolutionary. He had grown up at a time when the glorious days of Italian painting were over. The last great Venetian, Paolo Veronese,

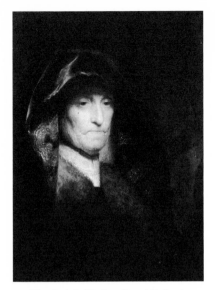

34 *The Artist's Mother. Royal Collection, reproduced by gracious permission of Her Majesty the Queen*

died in 1588, when Caravaggio was a boy. Roman painting had become fluent and decorative, or academic. Caravaggio reintroduced realism. At first he did so in a rather obvious way; his early naturalistic paintings have a kind of 19th-century vulgarity. Then he discovered the value of light and shade, by which he could both make a more dramatic effect and expose a little more of the truth. His *Calling of Matthew*, in the Church of S. Luigi dei Francesi in Rome, perhaps painted about 1600, is a turning-point in the history of art. As part of his quest for truth he rejected the fashion by which every figure had to be polished up to an ideal standard. In a famous picture, painted in the year of Rembrandt's birth, called the *Madonna of Loreto* [36], he included two poor people kneeling before her. His contemporary biographer writes 'he painted from life two pilgrims, the man with muddy feet and the woman with a torn, dirty cap, which caused great indignation'. In 17th-century Rome it was considered improper to paint from life, and a grave breach of decorum (a critical term then widely used) to represent in a sacred picture anything as common as dirty feet. But, although it was frowned on by all the connoisseurs, Caravaggio's revolution had the quickest and most widespread effect of any episode in the history of art. It transformed – one may almost say created – Neapolitan and Spanish painting; it had some

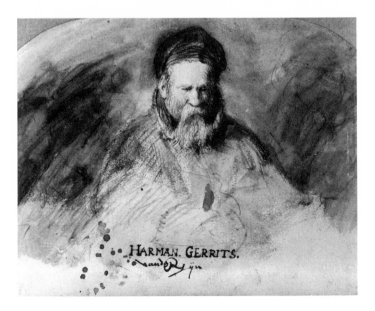

35 *The Artist's Father. Drawing. Ashmolean Museum, Oxford*

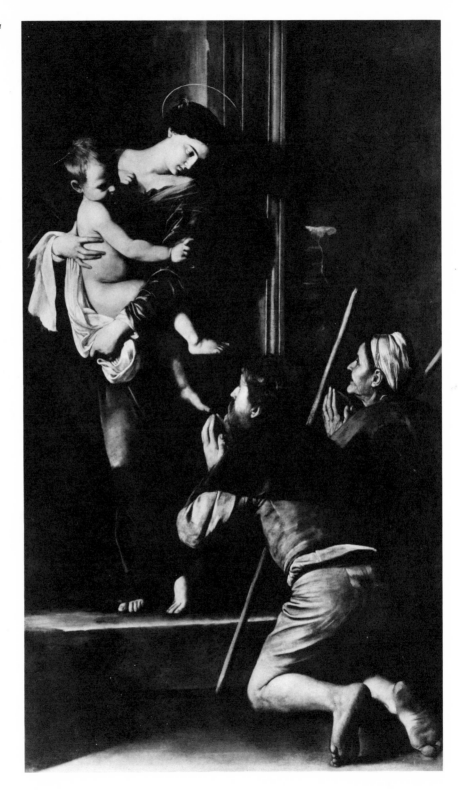

36 *Caravaggio. Madonna of Loreto. S. Agostino, Rome*

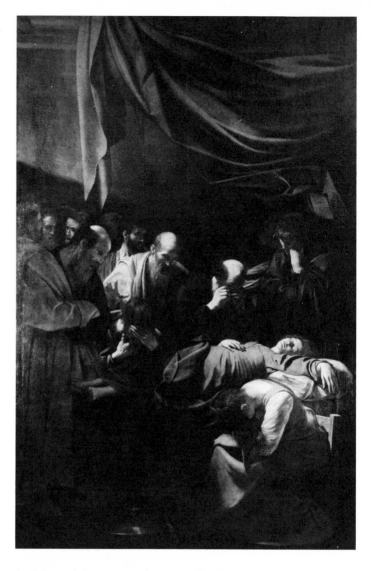

brilliant followers in France like Valentin and, as I have said, it spread to Holland, where the Utrecht painter, Honthorst, became a specialist in contrasts of light and shade, and perfected the genre of candlelight pictures.

I do not need to emphasise what an effect Caravaggio's revolution had on Rembrandt. It was an indirect influence. Rembrandt had probably never seen an original Caravaggio; his pictures were in Roman churches and the collections of Cardinals, and very few of them left Italy. Nor am I thinking so much of the influence of style. Many of Rembrandt's best early pictures are not painted with Caravaggio's violent

contrast of light and shade. Caravaggio, although he took his point of departure direct from nature, was basically a classical Italian artist, with a strong sculptural sense, and he would never have allowed himself the dramatic silhouette of Christ in the inspired early Rembrandt of the *Supper at Emmaus* [88]. Rembrandt took over some of Caravaggio's properties – furrowed brows and ragged clothes. But far more important was his affinity with Caravaggio's aims. Caravaggio's picture of the *Death of the Virgin* was rejected by the church that commissioned it because of its lack of decorum, that is to say that the Virgin looks so pitifully dead [37].

That Rembrandt's rejection of classical idealism was related to his sympathy for poor people was apparent to his contemporaries, and one of them called Joachim von Sandrart, a hack painter who moved from court to court and who was exactly Rembrandt's age, left a detailed description of him. He says that Rembrandt was an ignorant man who had not visited Italy, nor the places where the antique and the theory of art may be studied: 'He did not hesitate to oppose our rules of art, such as anatomy and the proportions of the human body, and the usefulness of classical statues.' 'The reason for this', Sandrart continues, 'was largely in his character for he did not at all know how to keep his station, and always associated with the lower orders, whereby he was hampered in his work.' Sandrart's description is full of inaccuracies, such as that Rembrandt could scarcely read, and that he did not paint poetical scenes; but that it was not wholly unfounded we can deduce from a better informed witness, the Italian art historian Baldinucci, who had talked to one of Rembrandt's pupils – a Danish painter named Keil. 'When he was at work', says Keil with a sort of reluctant admiration, 'he would not have granted an audience to the first monarch in the world.' Keil knew him late in life. One of his last self-portraits [38] shows why I said that Rembrandt remained a rebel till the end of his life. And, left over from the first chapter, is one of the first [39], an etching in which he has depicted himself in the guise of one of those tramps and beggars who were his friends, snarling at conventional society.

As a matter of fact the rebelliousness of his early

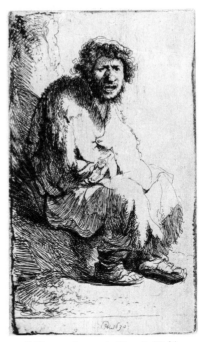

39 *Self-portrait as seated tramp. Etching*

40 *Nude woman seated. Etching*

41a *Woman bathing. Drawing. British Museum*

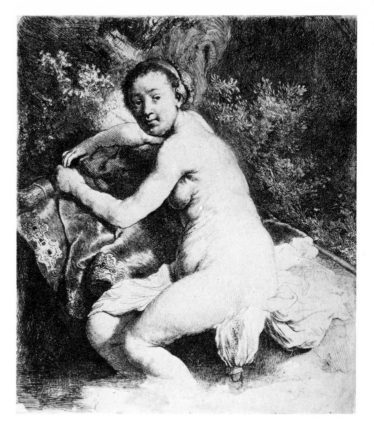

41b *Diana bathing. Etching*

work goes a great deal further than that of Caravaggio. It is not simply a question of naturalism. There is a conscious element of defiance. For example, when he made a drawing from life of a woman bathing [41a] it is what one might call an average body, not very elegant, but better than most. But when he turned the drawing into an etching [41b] he exaggerated every physical defect, and pointed the insult to ideal art by giving her the attributes of the goddess Diana. Contemporary critics were particularly worried because he had shown the marks of her garters – those garter-marks reappear in Rembrandt literature right up to the late 19th century. But this lady is almost attractive compared to the monstrously fat woman on plate 40. In this Rembrandt is doing more than indulging his passion for the truth. He is out to shock. No wonder that in front of works like this a Dutch poet named Pels called Rembrandt the first heretic in the art of painting.

The most disturbing and the most unforgettable of Rembrandt's anti-classical paintings is the *Rape of Ganymede* (1635), now in the gallery at Dresden [42]. It is a protest not only against antique art, but against antique morality, and against the combination of the two in 16th-century Rome. What led him to choose this subject in the first

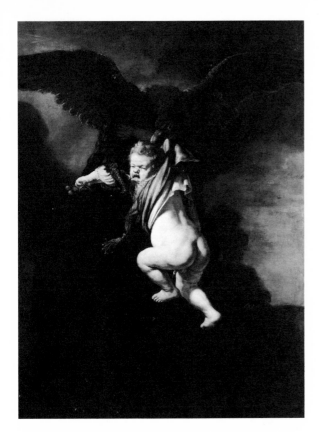

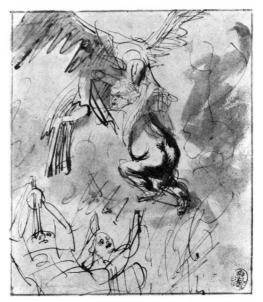

43 *Rape of Ganymede. Drawing. Staatliche Kunstsammlungen, Dresden*

42 *Rape of Ganymede. Staatliche Kunstsammlungen, Dresden*

place? Obviously he must have seen some 16th-century representation of the subject, and this was almost certainly an engraving after a drawing by Michelangelo. A drawing of the subject, in the Fogg Museum, was included in a recent exhibition at the British Museum, and accepted as the original of the engraving; but personally I think it too soft to be authentic. We may guess that Rembrandt's feelings were divided between admiration for the design of the Ganymede, with its acroterion eagle filling the sky, and a Protestant-Christian revulsion against the sexual practices of paganism that Michelangelo's version so clearly implied: for Rembrandt never looked at a motive without pondering on the full implications of the subject.

I think that Rembrandt was shocked, and he was determined that *his* picture should shock. But at the same time he could not resist the motive; and, as usual, he began to ask himself what the episode could really have been like. Well, he had seen a naughty child snatched up by its mother in very much the attitude of Michelangelo's Ganymede, and had delighted in its display of uninhibited rage [44]. Perhaps he had seen a similar episode with the child turned backwards on: at any rate he was fascinated by the bold curves of stomach and bottom, and a drawing

[43], also in Dresden, shows that at an early stage he made these interlocking forms the nub of his design. It is a powerful plastic idea: but, by showing the physical consequences of Ganymede's fear, Rembrandt has gone out of his way to repel us. And here we can see the contrast between him and Caravaggio, whose *Amor*, also derived from Michelangelo's Ganymede, with the eagle's wings sprouting from the boy's own shoulders, retains the shameless physical arrogance of antiquity. In the end I am not certain which of the two images is more

repulsive; but there is no doubt that Rembrandt's image gains something from his struggle against the potent charm of classic art. It is like one of those blasphemies which precede conversion.

I will give one more example of Rembrandt's desire to shock. In the engraving, from which he took the motive of Ganymede, is a dog with a spiky collar that, strangely enough, was part of Michelangelo's original design. This dog stuck in Rembrandt's imagination. At the same date he was doing an etching of *The Good Samaritan*. A few years earlier he had painted a small picture of the same subject, now in the Wallace Collection. Recent cleaning has shown that it is unquestionably authentic; it is signed RL and dated 1630. It

45 *The Good Samaritan. Etching*

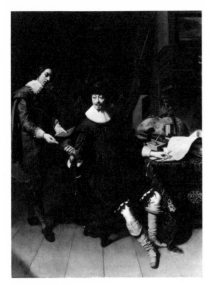

does not contain the dog that figures so prominently in the etching [45], answering a call of nature. I suppose that this is the first time this necessary action in our daily life had been recorded in art: it was meant to give us a jolt, and Rembrandt may have had an added pleasure in thinking that the dog derived from Michelangelo. But he meant also to remind us that if we are to practise the Christian virtue of humility, we must not avert our eyes from the humblest of natural functions, and curiously enough, the only critic to recognise his meaning was Goethe.

In the 17th century it was necessary for a young artist to have a patron, and in 1629 Rembrandt achieved one. He was 'discovered' by one of the most versatile men of his time – Constantin Huyghens. Huyghens was Secretary of State to the Stadtholder, Prince Frederick

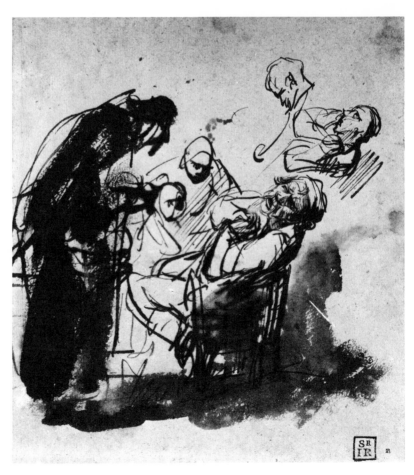

Henry of Orange. He looks pretty smooth in his portrait by Thomas de Keyser [46] but, apart from his official position, he had wide interests, in science, in philosophy, and he carried on a correspondence with Descartes in three languages; he was a musician, and he translated the poetry of John Donne into Dutch. In his diary he wrote, 'The miller's son Rembrandt and the embroiderer's son Lievens are already on a par with the most famous painters and will soon surpass them', and he adds the comment which I quoted in the first chapter that, whereas Lievens excelled in boldness of subject and grandeur of form, Rembrandt excelled in 'liveliness of emotional expression'. To prove his point he cites a picture of Judas returning the thirty pieces of silver. This, dated 1629, was the first of Rembrandt's works to make a powerful impression on his contemporaries, and Huyghens wrote of the figure of Judas, 'I am struck dumb by it. What this young man, a miller's son, a beardless boy, has done in summing up various emotions in one figure and depicting them as a single whole! Bravo Rembrandt!' The figure of Judas is indeed a marvellous dramatic invention, and his rejection by the priests is an early instance of Rembrandt's contempt for hypocrisy. Huyghens's comparison with Lievens is often criticised because in the end Lievens turned out to be a second-rate painter, but his judgment is not so foolish, because it was Rembrandt's gift for expressing violent emotion that distinguished him from the other northern followers of Caravaggio, like Honthorst, or indeed from Caravaggio himself. This extraordinary power of vitalising everything he depicted appears in his early etchings of his own face, or in such a drawing as that of Jacob being shown Joseph's bloodstained coat [47]. He was able to express liveliness of emotion, or the relationship between human beings, by the most liberated calligraphy that any artist has ever employed, even in the Zen painting of China. There is absolutely no interval of calculation between his feeling and the movement of his pen. Someone once asked a Chinese connoisseur, 'What is good calligraphy?' He replied, 'When you feel that if you cut a line, it would bleed.' That is true of Rembrandt's line, even in quite early drawings.

Huyghens secured for Rembrandt a very important commission from the Dutch Head of State, Prince Frederick Henry: a series of pictures of the Passion, that were to hang in the Royal Chapel. Commissions are often a mixed blessing to an artist; this one dragged on for years, and clearly became a great nuisance to Rembrandt. All of Rembrandt's seven surviving letters are addressed to Huyghens explaining, in the language usual among artists and writers of the period when addressing their patrons, why he had not fulfilled his obligations earlier. However, five of the pictures were completed, and one of them is a masterpiece, the *Entombment* [49]. I think it must have been painted last, because it is handled with far more vigour and concentration than the others.

While the commission dragged on, and became a bore, as most commissions do, Rembrandt contrived an enormous present for his patron. He knew that Huyghens, although the mildest of men, had a taste for violence and he determined to go to the limit.

The result was a picture about ten feet long by eight feet high of *The Blinding of Samson* [48]. Huyghens apparently declined this embarrassing gift; but Rembrandt stuck to his point and a few weeks afterwards wrote another obsequious letter in which he says, 'even against my Lord's wishes I send you the accompanying canvas, hoping that you will not mistrust my motives, because it is the first token I offer my Lord'. He added, 'My Lord, hang this piece in a strong light, so that it may best vouch for itself.' The evidence is not quite conclusive, but on the whole it looks as if Huyghens got the Samson after all.

The Blinding of Samson is an extremely disturbing picture. Only a man of genius could have done anything so consistently horrifying.

48 *The Blinding of Samson. Städelsches Kunstinstitut, Frankfurt-am-Main*

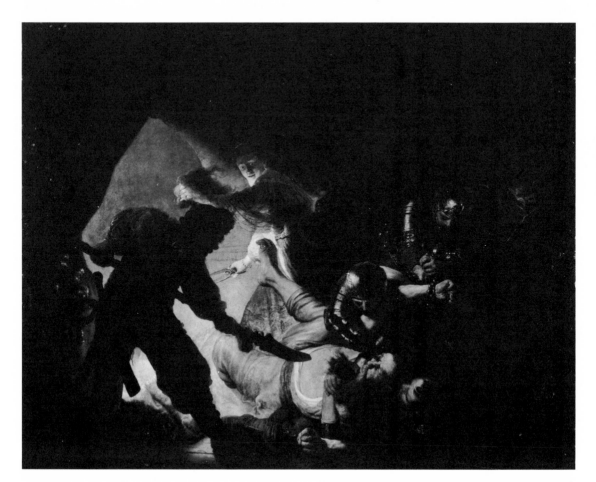

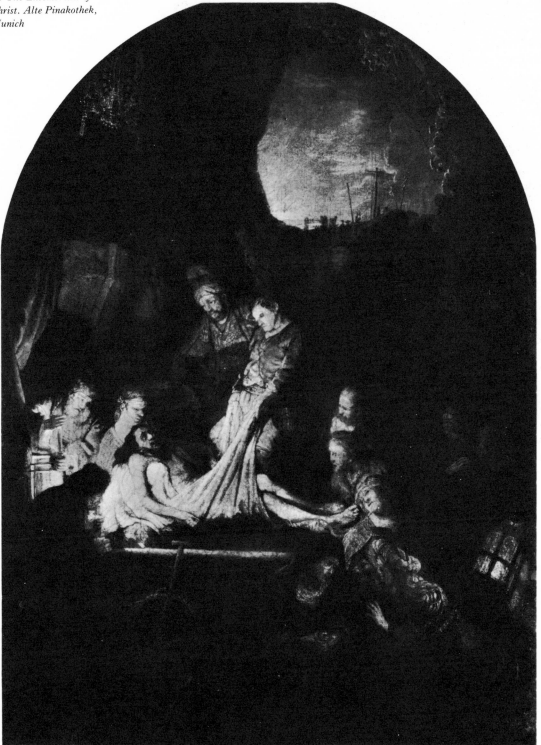

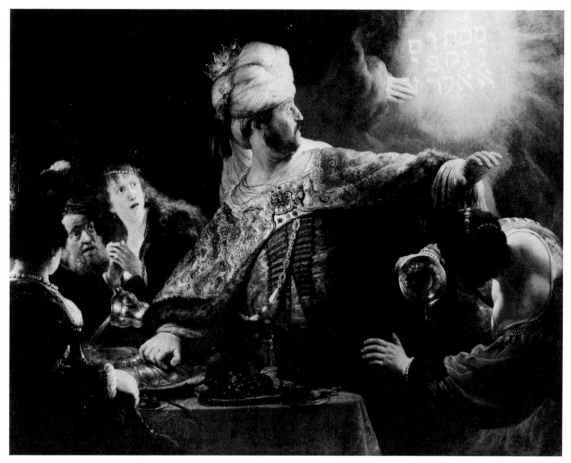

Apart from the revolting realism of the actual blinding, every detail, every hand and foot, is ugly in itself. The silhouette of the man on the left has the same character as the dog in *The Good Samaritan*. His trousers are like the hideous legs of Jacobean sideboards. But as a feat of pictorial imagination it is appallingly effective. A wave of light, which seems to have burst through a broken dam, overwhelms the miserable Samson, and then is gone from him for ever. The grotesque halberdier, pointing his weapon at the fallen giant like a stoker, looks at his victim with a startled compassion; he has the shagginess and irregularity of the North. The men who blind Samson and put out his eyes are from the South, and are, in fact, reminiscences of the guards in Raphael's *Liberation of St Peter*. They are concentrating relentlessly on their task. And what about Delilah? No brutality, not even an obvious look of triumph. Just excitement, as if she had won a game.

For Rembrandt, the painting of Samson was therapeutic. In following the development of his mind, one feels that at certain points

he has to get things out of his system. Here he has worked off all the need to make a violent impact against the restrained gestures of classicism. In fact he never ceased to be passionately interested in the emotions revealed by the human face; but thenceforward he set about conveying them more subtly.

The Blinding of Samson is sometimes spoken of as an example of the baroque style: but if we use that word accurately – in a sense that covers the mature Rubens and Bernini – then it should not be applied to Rembrandt's picture, because true Baroque aimed at a unifying flow of movement based on curves, a feeling for continuity extending from the parts of the composition to the whole. In the *Samson* the abruptness of the transitions, the absence of flowing movement and the uneasy fragmentation of area are all contrary to true Baroque. The word I used earlier, Jacobean, seems more apt. And the same is true of another ambitious attempt to portray a dramatic moment in the Old Testament *Belshazzar's Feast* [50]. It is arresting, but full of faults that the most modest Roman follower of Lanfranco would have known how to avoid. The diagonal of Belshazzar's arm, and the empty pool of darkness under his cloak, result in a discontinuity that is entirely un-Baroque. I may add that the foreshortened woman on the right is taken direct from Paolo Veronese. Like all great artists Rembrandt was an avid borrower,

52 *Samson betrayed by Delilah. Staatliche Museen Preussischer Kulturbesitz, Berlin Gemäldegalerie*

51 *Rape of Proserpine. Staatliche Museen, Preussischer Kulturbesitz, Berlin Gemäldegalerie*

53

although he usually covered up his tracks more carefully than he has done here.

However, the young Rembrandt did several pictures and one etching that can properly be called Baroque, and they are amongst the best of his early works. The first of them also represents Samson and Delilah [52], but it is a complete contrast to the blinding picture. It has continuous flow of light and a movement into depth that illustrates perfectly my definition of Baroque. Incidentally, the Macbeth-like figure in the back must be one of the earliest representations in art of a kilt and plaid. How did Rembrandt come by it? Had he seen a drawing of a Highlander, or is it based on some engraving of a barbarian on Trajan's Column?

The other early Rembrandt in the baroque style that I find enchantingly beautiful is a small picture the *Rape of Proserpine* [51]. It was admired from the first; it belonged to Prince Frederick Henry, and is the kind of Rembrandt that influenced the French painters of the 18th century. The way in which Proserpine is illuminated, like a jewel set off by the surrounding darkness and the abrupt diagonal of her chariot, reveal an entirely original vision. Yet we know that Rembrandt took the idea of the chariot and the plunging horses from Rubens; and if we compare the two designs we can see how little in the end Rembrandt paid attention to the fluent conventions of Baroque. He could not bring himself to accept the ineffectual eloquence of those flung-back arms by which, in all classic art, the heroines of antiquity inform us that they are being raped. What would a decent Dutch girl do in the situation? Kick, and scratch his eyes out. And this Rembrandt's Proserpine is doing so effectively that the swarthy, oriental Pluto has turned away his head in alarm.

There couldn't be a simpler example of the need for truth which directed the young rebel, even in one of his most poetical visions.

The work in which Rembrandt tried hardest to come to terms with the convention of baroque art is a large etching of the *Death of the Virgin*, dated 1639 [53]. He has even allowed the intrusion of angels on clouds. But they are of no importance. The dying woman does not look up to them with certainty of salvation, as she would in a Bolognese or Roman picture. On the contrary her head has slumped pitifully on its pillow, and one of the Apostles wipes her lips, while another takes her pulse: the truth – observed in more factual detail even than in the Caravaggio. And how typical of the way in which Rembrandt had come to terms with life is the contrast between the agonised woman holding the pole of the bed and the two sitting on the steps with their backs to us, who couldn't care less, and are enjoying a good gossip.

The most obvious – almost painfully obvious – example of the discrepancy between the mechanics of the baroque style, and Rembrandt's total absorption in the varieties of human life and

53 *Death of the Virgin. Etching*

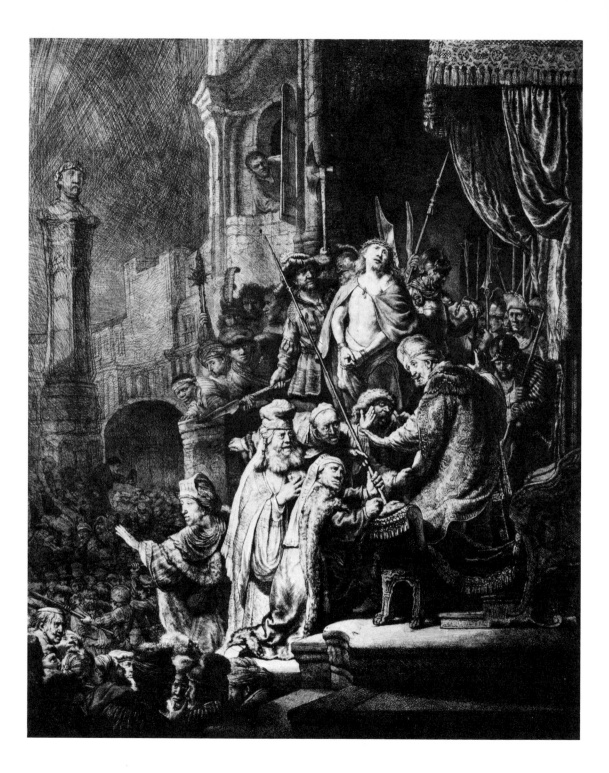

54 *Christ before Pilate. Etching*

behaviour is also to be found in an etching, the *Christ before Pilate* [54], executed in the same year as *The Blinding of Samson*. The figure of Christ, taken direct from Guido Reni, is totally unreal. But Pilate and the outraged members of the ecclesiastical establishment, who press round him and try to ensure Christ's conviction, are observed with the appetite of a Balzac. Pilate himself is a typical colonial administrator, half-way between a civil servant and a retired general, and the futile deprecatory gesture with which he attempts to restrain the angry priests is perfectly observed. The priests themselves are a repertoire of theological odium; hypocrisy, fanaticism, senile obstinacy and care for vested interests are all represented. The depiction of lively emotions, praised by Huyghens, could hardly go further. But when one ceases to read the etching like a novel, one suffers a real feeling of discomfort. The composition is without any unifying movement, and grubs its way upwards like a molehill. This is partly due to the amount of definition that Rembrandt has put into his overworked etching (all his life he had a curious urge to carry etchings to a point of finish where the character of the medium is lost), because in the oil-sketch of the same theme the modulation of light and shade has given the group a unity that it lacks in the more detailed etching.

Rembrandt never allowed himself to be deflected from the truth by the beautiful falsehoods of classical imagery. A small and almost comical example is an etching, done as an illustration to a book by his friend Menasseh ben Israel, of the image seen by Nebuchadnezzar [56]. Anyone else would have made it into a classical Apollo; even although it had feet of clay, its upper half should be imposing. Rembrandt's idol is a life-drawing of a somewhat exhausted model, thin, scraggy, and pathetically unimposing. We remember Sandrart's reproach that 'he did not appreciate the usefulness of classical statues'. This is shown with greater dignity in some of his later etchings of naked women. Throughout his life he did studies of nude models that are quite attractive, sometimes almost like French 18th-century drawings. But when he committed himself to the more permanent medium of etching, then he felt that truth must be emphasised at the expense of charm, and this elderly body, which has resisted long usage like an old boat, is better worth perpetuating than the pretty ones.

Rembrandt recognised that full, round curves had become one of the deceptive clichés of classical art. And in nothing were they more indicative of power and pomp than in the smooth swelling rumps of horses. The horses in Rubens or in Velazquez's portrait of the Duke of Olivares assert by their great curves the power of their riders. No doubt 17th-century horses really did have much heavier hindquarters than show jumpers have today, but even so, there is an element of symbolism

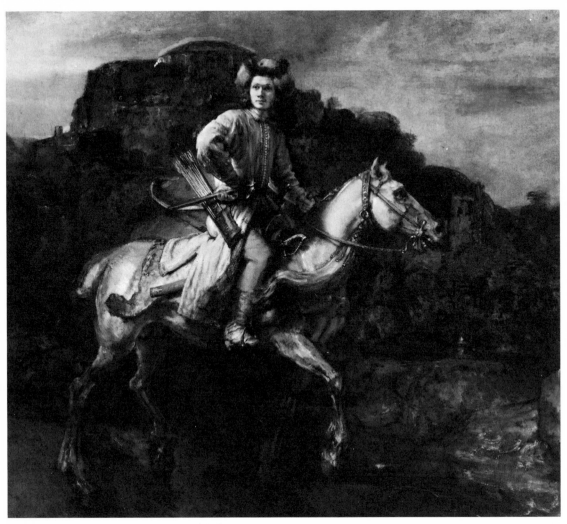

55 *The Polish Rider. Frick Collection, New York*

in these powerful arcs. This was precisely the kind of assertiveness against which Rembrandt all his life was in rebellion. For this reason he seldom introduces a horse into his work, and yet it is the subject of one of the most personal and mysterious of his later paintings – the so-called *Polish Rider* [55].

The genesis of this magical work is typical of Rembrandt. It began, I think, when he saw a skeleton horse and rider in the anatomy school at Leyden, and made a brilliant drawing of it [57]. The rear legs and quarters, the very negation of the triumphal arc, are used practically without alteration in the picture. But the skeleton's forelegs did not satisfy him and so he turned to a still less buoyant image: the horse ridden by Death in Dürer's print of the *Four Horsemen of the Apocalypse*. The head of Death's horse is appropriately miserable, and Rembrandt wanted his horse's head to express aspiration. Plastically it is as significant as the horse's head from the Parthenon. Also it has a soul. And so this physically unimposing animal becomes the proper vehicle for its mysterious rider.

56 *The Image seen by Nebuchadnezzar. Etching*

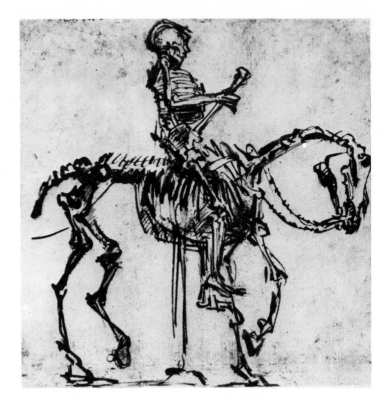

57 *Skeleton rider. Drawing. Hessisches Landes Museum, Darmstadt*

This Christian knight has an almost feminine beauty. I believe that the *Polish Rider* was painted from the same model who appears as Potiphar's wife, in the two versions of *Joseph and Potiphar*, and was perhaps the same woman who is the subject of a drawing in the British Museum. His gaze, like that of his horse, is focused on some unattainable objective. His dress and equipment are said to be derived from those of the Hungarians who fought with the infidel invaders. What a weird combination! Yet through Rembrandt's imagination it has become perfectly consistent, and is one of the great poems of painting.

The end of Rembrandt's career as a rebel has an appropriate flavour of irony. In 1655 the new Town Hall of Amsterdam was being decorated by the most esteemed painters. The directing voice was that of the famous poet van Vondel (the Dutch Milton), who advised allegories in the ideal baroque manner; and he had a low opinion of Rembrandt. However, a few people who remembered his earlier reputation were able (owing to the death of a successful painter named Flinck) to secure for Rembrandt one of the commissions. It was to represent a scene from Tacitus, where Claudius Civilis, leader of the Dutch resistance against the Romans, invites his countrymen to a midnight banquet, where they will swear an oath of rebellion [58]. We have a very summary indication of the vast canvas in a small drawing, and see that behind the main group there was a moonlit landscape. It was sent to the Town Hall, found unsuitable and returned. Dutch art historians, jealous for the good name of their countrymen's taste, have tried to make out that this happened because it did not fit the space. But I think one need only look at the surviving fragment to see why official opinion could not accept it. Perhaps Rembrandt, when he cut it down, repainted it, and made it even more unconventional. It is a most marvellous picture, but in places it borders on the absurd. The word 'Shakespearean' is, for once, justifiable. Rembrandt has evoked the kind of quasi-mythical, heroic-magical past that is the setting for King Lear and Cymbeline and, as with Shakespeare, this remoteness has allowed him to insert into an episode of primitive grandeur the life-giving roughage of the grotesque. The characters at the extreme end of the table, left and right, are equivalent to the porter in *Macbeth* or the gravedigger in *Hamlet*, and, just as the unclassical elements in the plays are immersed in a stream of glorious language, so Rembrandt's conspirators are transfigured by paint of the most exquisite colour and texture.

No great artist is entirely consistent. I said in the first chapter that Rembrandt felt in his own character something kingly, and expressed it in his self-portraits. But when we think about his philosophy as a whole we can have no doubt about his repudiation of official values. He was as

much in rebellion against the classical legacy of Rome as were Claudius Civilis and his friends. On the contrary, he turned to the ethos of Judaism, and to a large extent his rebellion illustrates that sublime Judaic hymn which St Luke puts into the mouth of the Virgin Mary: 'He hath put down the mighty from their seats and exalted them of low degree. He hath filled the hungry with good things; and the rich He hath sent empty away.'

58 *Conspiracy of Claudius Civilis. National Museum, Stockholm*

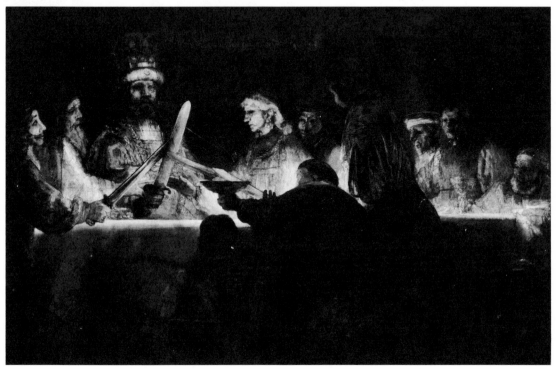

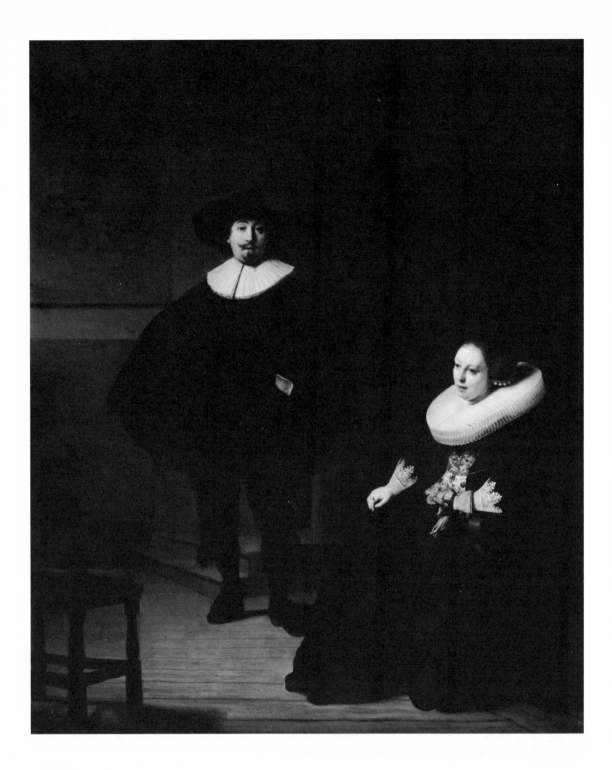

59 *Portrait of a man and woman in black. Isabella Stewart Gardner Museum, Boston*

The Success 3

By 1631 it became obvious that the charming provincial town of Leyden was not big enough for Rembrandt's bursting gifts; he must go to the great new city that had become the commercial capital of the Netherlands, Amsterdam. It had grown up very rapidly as a result of the closure of the port of Antwerp, and the beautiful houses that line its canals, and seem to have been there for ever, were then being built at an alarming speed. It was, and remained throughout Rembrandt's lifetime, a developer's paradise, but what a contrast to the developers of today. Never has capitalism shown a rosier face than in Amsterdam of the 1630s, and, as usually happens in these first expansions of bourgeois culture, people wanted to have their appearances perpetuated by art. The leading painter in Amsterdam when Rembrandt went there was Thomas de Keyser, and he was in fact the son of the architect Henrik de Keyser, who was giving Amsterdam the aspect which it has borne to the present day. He was a smooth, useful painter, and I have already illustrated [46] his portrait of Rembrandt's first patron, Constantin Huyghens. This was the style that, in his first two years, Rembrandt was prepared occasionally to imitate, and although in such a picture as the double portrait in Boston [59] his sitters look a trifle less elegant and more real, the man not so pleased with himself as he would like to be, the woman lost in apprehensive reverie, it is a variation of a fashionable theme. It happened that only twelve miles away, in the more modest city of Haarlem, a great portrait-painter had established a practice during the preceding fifteen years, Frans Hals. After having excited the passionate admiration of Manet, Sargent and all the great portrait-painters of the 19th century, Hals passed into critical disfavour. He was considered shallow and vulgar. But even in his acceptance of a rather boisterous convivial life, one can see that he was a painter of genius. Perhaps one has to be a painter to recognise his technical skill, but everyone must admire his grasp of character, not only in the individual portraits, but in the heads which, with amazing variety, occupy his groups. That these two great portrait-painters, living so near each other (Hals with a ten-years' start), seem to have had absolutely no *rapport* with one another throws a light on the isolation of local schools in the Netherlands. There is no record of their having met, and only occasionally do we feel in Rembrandt's work a consciousness of Frans Hals.

Rembrandt, as I have said, went to stay in the house of the picture-dealer van Ulenborch, to whom, for some mysterious reason, he had lent 1000 guilders; another proof that he wasn't at all the poor boy from the provinces who appealed so strongly to sentimental writers of the 19th century. This suited him well. He wanted to learn all he could about the art of the past. Rembrandt didn't need to be taught anything about the representation of movement, or facial expression, but he did want to learn something about the science of picture-making, how to build up a big composition so that it holds together: and this had been the particular achievement of Italian art of the High Renaissance. In the ordinary way a young painter of his gifts would have gone to Italy, and Huyghens advised him to do so, to which Rembrandt replied simply that he was too busy.

But in fact he saw a great deal of Italian art by staying at home. Amsterdam had become the centre of the world art market; prints and pictures were sent there for sale from all over Europe, and a number of them passed through van Ulenborch's premises, where he employed a number of young painters in copying them. From the first, Rembrandt bought some of them himself. One of them was a print after Leonardo da Vinci's *Last Supper*. This print, the earliest of the many reproductions of this famous work, is by an anonymous engraver called the Master of the Sforza Book of Hours, and we know that it was Rembrandt's model, because, for some frivolous reason, the engraver

60 *The Last Supper, after Leonardo da Vinci. Drawing. Metropolitan Museum of Art, The Robert Lehman Collection 1975, New York*

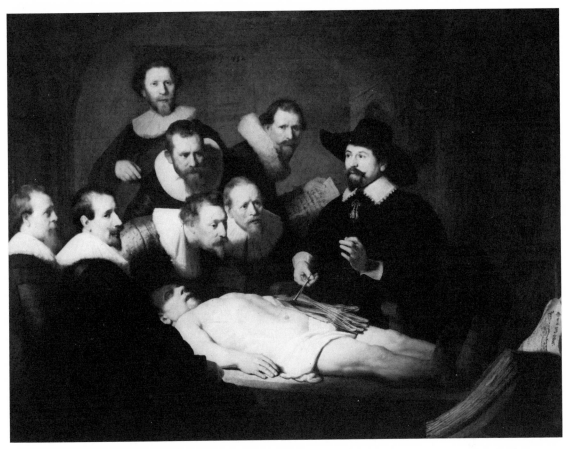

had inserted in the right-hand corner an animal, usually described as a dog, but actually derived from one of Leonardo's curious-looking cats, such as those in a famous drawing in Windsor. This animal appears in Rembrandt's copy. The print gives a feeble idea of the power of the original, and Rembrandt's first copy of it [60], done in a hard red chalk, was rather timid and niggling. One can still see a trace of it in the Christ's head. Then, quite shortly afterwards, he must have seen a more spirited version of *The Last Supper*, perhaps a painting, and he went over his original copy with bold chalk strokes. It was at this point that he absorbed the motives that were to mean so much to him – the diagonal recoil of the Judas, the sweeping gestures of St Bartholomew looking one way and pointing another, the isolation of Our Lord. In all his hundreds of illustrations to the Bible, Rembrandt never attempted the subject of the Last Supper. Leonardo had done that once and for all. But it was always at the back of his mind, and an attentive eye can see memories of Leonardo's masterpiece appearing in pictures, etchings and drawings all through his life.

Within a year of arriving in Amsterdam Rembrandt painted the kind of picture that puts a young painter on the road to worldly success, a group portrait of a famous surgeon named Dr Tulp giving a demonstration of anatomy [61]. The onlookers were not students, in fact none of them even held a medical degree, but members of the Surgeons Guild, who had paid to have their handsome heads included. Two of them seem to have sent in their subscriptions late, the man at the back and the man on the left-hand side, who was probably added by a pupil. Dr Tulp himself was the most successful practitioner of his time, and, in addition to his unrivalled position as a doctor, he was City Treasurer of Amsterdam and Burgemeester. He is the image of the persuasive Harley Street man. It was a picture of the Establishment (except for the unfortunate criminal, a Leyden man called Aris, whose corpse was being dissected) and for the Establishment. And yet one can see why it made such an impression on contemporaries. Dissections of corpses were rare and solemn events, and Rembrandt has expressed this feeling both in the concentrated design and in the skilfully varied heads of the three men who are looking on (the other four are paying no attention, and are simply there to get their money's worth). Even Dr Tulp's smooth countenance is lit up by a faith in the new knowledge and the triumph of science. It is, so to say, a 'picture of the year', but of an important year; and it is done with incomparable skill.

Dr Tulp's Anatomy Lesson made Rembrandt's name as the outstanding painter of Amsterdam, and for twenty years he was never without a portrait commission. But to call him a fashionable painter is misleading, for very few of his sitters were men of fashion as, for example, were the sitters of Van Dyck. The furthest he went in that direction is a full-length portrait of an unknown man in a Van Dyck pose, which makes him look slightly ridiculous. He also did a couple called Marten and Opjen Soolman, who are very fashionably dressed, and Rembrandt has enjoyed his sitters' garters and preposterous shoes. Most of his portraits were of well-to-do merchants, like Marten Looten and, although they do not enchant us as his later portraits do, they are good, straightforward jobs. The best of them represent preachers, Johannes Uytenbogaert, the Arminian Remonstrant, Johanus Elison, a Church of England preacher in Norwich, who visited Amsterdam in 1634 and, most persuasive of all, Eleazar Swalmius.

No doubt Rembrandt was glad to discuss with these eminent divines the interpretation of the Scriptures that continually occupied his mind. Of particular interest is his drawing of Anslo, not only because it is a masterpiece, but because Anslo was a Mennonite. Rembrandt was to become more and more closely associated with the sect of the Mennonites and, although we have no documentary evidence for saying so, the pictorial evidence suggests that Anslo had a crucial influence on

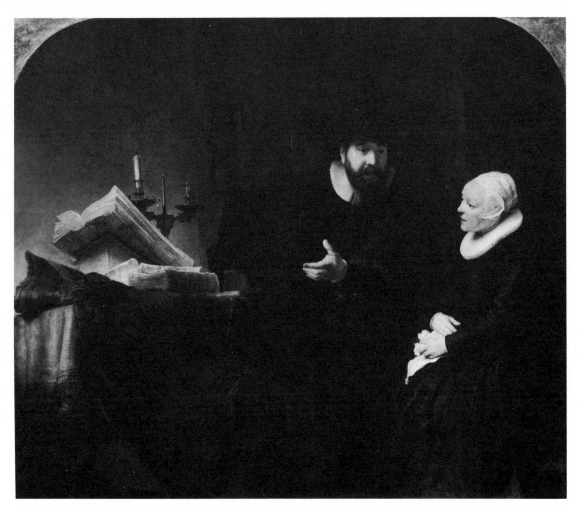

62 *Portrait of Anslo and a disciple. Staatliche Museen Preussischer Kulturbesitz, Berlin Gemäldegalerie*

his religious thought. Later he did a beautiful double portrait of the great man expounding a point of doctrine to a woman disciple, just as he must often have done to Rembrandt [62].

The double portrait is a notoriously difficult form, but Rembrandt liked it because in it he could display his gift for vivacity of expression, and he had already practised it in a picture he painted immediately after *Dr Tulp's Anatomy Lesson*, representing a shipbuilder seated at his desk, whose wife is bringing him an urgent message [63]. It is a masterly piece of work. But if Rembrandt had done nothing but pictures of this kind we should not feel about him as we do.

The Shipbuilder is dated 1633, and he continued to do portraits of local worthies in black clothes for another six or seven years. The style does not vary much, although I think one feels an increase in mastery –

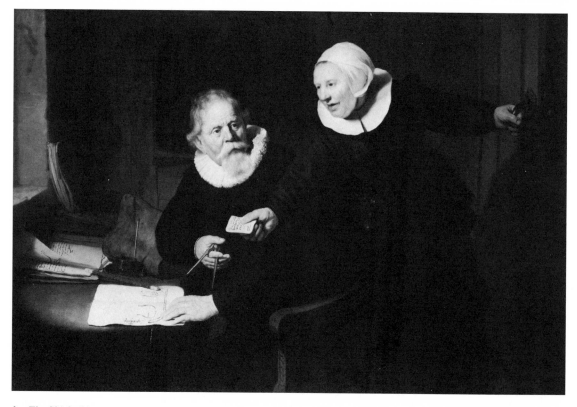

but this may depend on whether the sitter was sympathetic. For example he obviously liked Herman Doomer the framemaker (1640) [64] because he looked like an honest craftsman, and he was touched by the self-contained seriousness of Mrs Van Bambeek (1641) [65]. Portrait-painting, like architecture, involves a subtle relationship between the artist and the client, and if even the most narrowly professional portrait-painters, like Reynolds and Sargent, could find their talents turned off or on by the personalities of their sitters, how much more was this true of an artist as aware of human relationships as Rembrandt.

During this period of hard professional work Rembrandt made a perilous decision. He married. His bride was the first cousin of the art-dealer in whose house he had been living, Saskia van Ulenborch. She came from Friesland, where her father had been a man of property. Socially she was in a different class from Rembrandt. He may have met her first as a young girl, when the difference would not have been so obvious. The first evidence we have that he knew her is a drawing of her in silver-point inscribed 'This drawing of my wife was done when she was twenty one years old, the third day after our betrothal' [66]. He has dressed her in a broad-brimmed country hat which has made her look

almost beautiful. It is one of the sweetest drawings in the world. They were married the following year, 1634, and Saskia brought with her a substantial dowry, which was tied up in such a way that he couldn't spend the principal.

Rembrandt must also have been making a considerable income from his portraits. Where did all the money go? Partly on collecting; Rembrandt was an insatiable collector. He could not admire things with detachment; he needed to possess them, and, of course, some of the things he needed were really part of his stock-in-trade. In his Inventory we find many references to old armour, gold helmets and weapons, fur caps and cloaks and embroidered shawls. The fact was that he got sick of painting all those virtuous preachers and merchants in their black hats, and longed to indulge the side of his

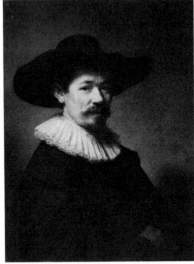

64 *Portrait of Herman Doomer. The Metropolitan Museum of Art, Bequest of Mrs H. O. Havemeyer, 1929, The H. O. Havemeyer Collection, New York*

65 *Portrait of Agatha Bas, Mrs Van Bambeek. Royal Collection, reproduced by gracious permission of Her Majesty the Queen*

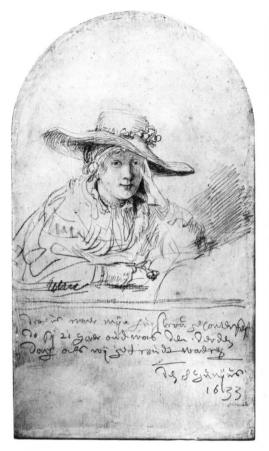

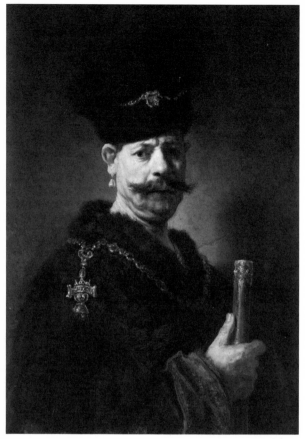

66 *Portrait of Saskia, 1633. Drawing. Staatliche Museen Preussischer Kulturbesitz, Berlin Kupferstichkabinett*

67 *The Polish Nobleman. National Gallery of Art, Mellon Collection, Washington*

character which delighted in rich textures and exotic garments. During the 1630s fashion in the Netherlands passed through a period of puritanism. The flowers on Mr Soolman's shoes were ridiculed in a poem. Black became the order of the day. This did not suit Rembrandt at all, and it was in reaction against it that he painted the once-famous portrait known as *The Polish Nobleman* [67], which personally I believe to be an idealised portrait of Rembrandt himself got up in fancy dress. It was a relief to do that after the *Marten Looten*.

This delight in dressing up reached its climax in the pictures he painted of Saskia in the first years after their marriage. Two of them represent her as a goddess of spring carrying a thyrsis, a staff wound round with flowers. The earlier, in the Hermitage [68], which is dated the year of their marriage, is the more touching as Saskia gazes at us from under her crown of flowers, with a kind of patient innocence. In the National Gallery picture [69], painted the following year, she seems to have grown more accustomed to her role as model; and it must have been a heavy one, for she was weighed down by her sumptuous clothes,

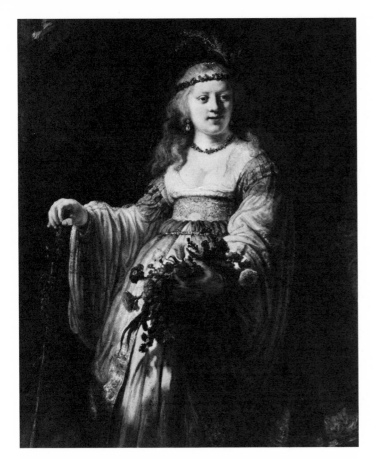

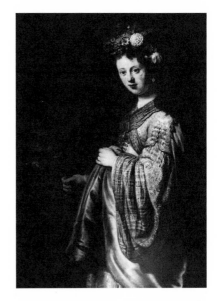

68 *Saskia as Flora. National Gallery, London*

69 *Saskia as Flora. Hermitage, Leningrad*

and the sittings must have taken a long time for the picture is painted with a richness of handling he had hardly ever attempted before. He revels in the thick, rich paint with which he renders every detail. This is an approach to the technique of painting very different from the thin, smooth handling of *Dr Tulp's Anatomy Lesson*, and it reveals a sensuality which he normally repressed, but which, in a sublimated form, was to become the basis of his latest pictures. There are two more of these 'dressing up Saskia' pictures, both at Dresden, and humanly they are a curious contrast to each other. One of them [71], perhaps the earliest, is painted with unselfconscious mastery, and is one of Rembrandt's most ravishing works. It shows Saskia in a plumed hat, which casts a beautiful, transparent shadow over her forehead. She looks at us with smiling eyes and her jolly smile has delved a dimple on her cheek. One

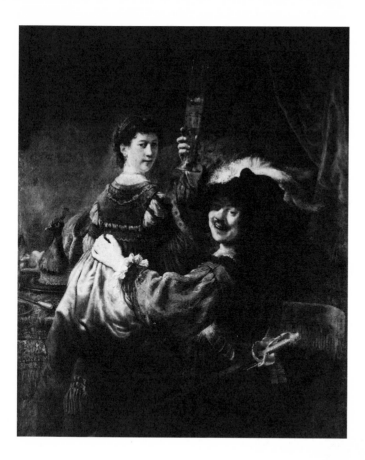

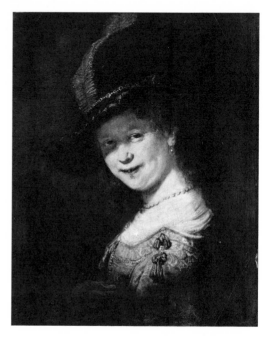

71 *Portrait of Saskia
with a feathered hat.
Staatliche
Kunstsammlungen,
Dresden*

hopes, for Rembrandt's sake, that she often looked like this. The other is the famous portrait of Rembrandt with Saskia on his knee [70]. Although once amongst the most popular of Rembrandt's works, it is actually one of the hardest to explain. The part of jolly toper was not in his nature, and I agree with the theory that this is not intended as a portrait group at all, but as a representation of the Prodigal Son wasting his inheritance. A tally-board, faintly discernible on the left, shows that the scene is taking place in an inn. Nowhere else has Rembrandt made himself look so deboshed, and Saskia is enduring her ordeal with complete detachment – even a certain hauteur. But beyond the ostensible subject, the picture may express some psychological need in Rembrandt to reveal his discovery that he and his wife were two very different characters, and if she was going to insist on her higher social status, he would discover within himself a certain convivial coarseness.

Rembrandt's choice of subjects is never accidental, and from an early date he had felt himself involved in the story of Samson and Delilah. He was disturbed at the thought of what an ambitious woman could do to destroy a man. Four years after his wedding he painted his greatest

72 Samson's Wedding Feast. Staatliche Kunstsammlungen, Dresden

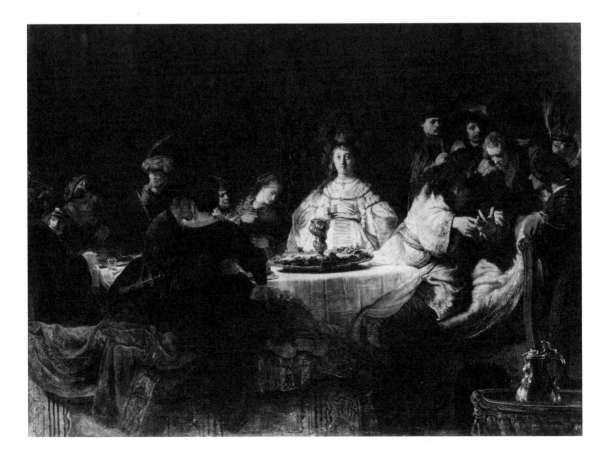

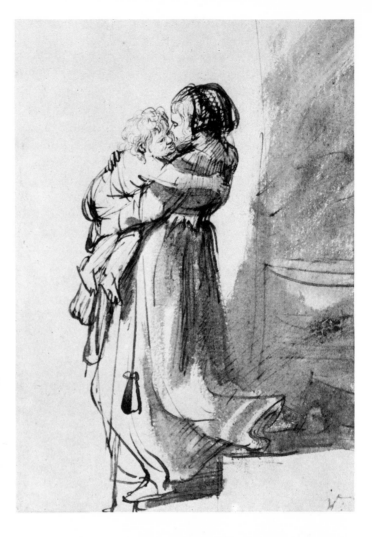

Samson picture, the *Samson's Wedding Feast*, now in Dresden [72]. At
this feast Samson asked the riddle – What was the meaning of the words
'Out of the strong came forth sweetness.' The thirty companions of his
bride (who was not, of course, Delilah, but a Philistine lady, never
named) could not guess it, but after seven days of feasting they
persuaded her to wheedle the answer out of Samson. He guessed what
had taken place 'And he went down to Askelon, and slew all thirty of
them'. In the picture the lady from Timrath sits alone, sly, watchful,
well fed, obviously one of the enemy's party, while her somewhat over-
dressed husband propounds his riddle with a marvellously observed
gesture. It seems almost sacrilegious to point out that the central figure
is a memory of Christ in Leonardo's *Last Supper*, but her pale isolation
in the middle of the table makes it unquestionable, Rembrandt himself,
disguised as a turbanned flute-player, looks on with a curious mixture of

75 *View of a bedroom. Drawing.*
Rijksmuseum, Amsterdam

76 *View of a bedroom. Drawing. Fondation*
Custodia, Collection F. Lugt, Institut
Néerlandais, Paris

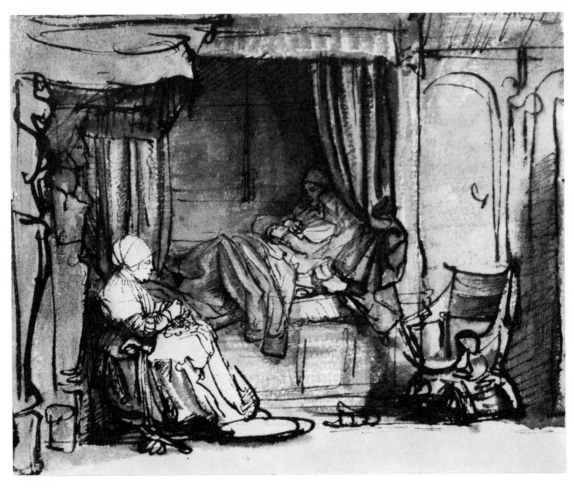

pity and detachment.

Not that Saskia had much opportunity of betraying Rembrandt to the Philistine upper class to which she belonged: she spent most of her time ill in bed. She had four children, of which all but one – Titus – died in infancy, too young even to have been the subjects of the beautiful drawings of toddling and screaming children that Rembrandt did in these years. The one on plate [73] is usually known as *Saskia and Rombartus*, but Rombartus died at the age of exactly two months, so it must be Titus. Rembrandt often drew Saskia in bed, with the fixed stare of someone who is without hope. He made several drawings of her bedroom, very untidy and miserable [75], and then [76] of another room which suggests that the bed had been carried down to the parlour, as in it we see an indication of a grandiose chimney-piece which, we know from other drawings, was the central feature of that room.

This was clearly done in Rembrandt's new house. He purchased it in 1639 for the considerable sum of 13,000 florins. He put down 1200, but he never paid off the whole sum – I can't think why, because both he and Saskia had plenty of money. It was a large house in what was then a fashionable quarter, the Breestraat, and was a bit too grand for him. It is still there – in a sense. The front has been changed, as one can see from an old engraving, and of the interior nothing remains as it was in Rembrandt's time. The street as a whole has been pulled down and made into a motorway: Anne Hathaway's cottage is more authentic. It used to be supposed that he needed a big house because he had so many pupils; and it is true that for years he had upwards of fifty at a time, including almost all the best Dutch painters of the next generation. But it seems that his teaching studio was a shed some distance away.

He bought his big house because, in spite of his sympathy with the humble and meek, Rembrandt enjoyed showing off. This is evident from the two etched self-portraits [12 and 16] done in the first five years after his marriage, the last one in the year he purchased his house. Saskia was still holding her own in 1638; but a year or two later she was defeated. Rembrandt made a very small, infinitely touching etching of her, which seems to have been breathed on to the copperplate by a sigh [74]. Poor Saskia: she died in June 1642. Should we say 'Poor Rembrandt'? This leads us to consider one of the most beautiful and baffling of all his works, the *Danaë* in the Hermitage [77]. It is dated 1636, and was conventionally supposed to represent Saskia; but it bears no resemblance to her, and from all we know of her I cannot believe that she would have allowed herself to be represented in this pose. Perhaps the actual body was repainted later, but the details are in the style of the 1630s, and the welcoming gesture of the nude figure cannot have been greatly changed. We must, I think, assume that Rembrandt, like any other artist, lived on two planes. His heart and his sympathy were

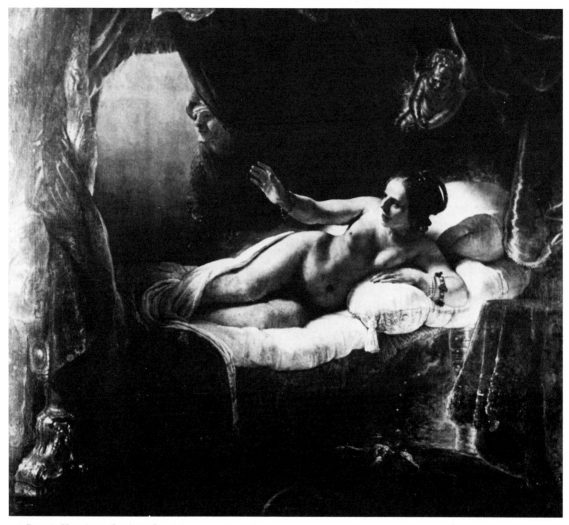

77 *Danaë. Hermitage, Leningrad*

moved by his unfortunate wife; but his senses were imperative, and he had gratified them by painting a picture of uninhibited sensuality.

At the height of his anxieties over Saskia, in fact in the year of her death, Rembrandt received his most important commission [78]. This was from a company of musketeers called the Kloveniersdoelen, who had a fine house in the same street as Rembrandt. The head of the Company was called Captain Frans Banning Cocq. It had long been the practice for Dutch guilds, companies or civic guards (which were really only clubs) to have group portraits painted, and at first they were quite prosaic – simply rows of likenesses. Then in the 1630s Frans Hals made them into the convivial gatherings to which I have already referred. Perhaps Rembrandt had such pictures in mind when he accepted the

78 *The Night Watch.*
Rijksmuseum,
Amsterdam

commission from Captain Cocq, who was extremely rich, to paint an
even larger and more ambitious guild picture and felt that this would be
an opportunity to restore the dignified status of a guild. He intended to
show Captain Cocq leading his company out into the sunshine. By the
early 19th century the varnish had darkened to such a degree that it was
referred to as *The Night Watch*, and although it has now been well
cleaned, so that its original intention is evident, the familiar title is still
current usage.

The Night Watch is an extraordinary *tour de force*. To paint on such a
scale without a single dull patch, to keep the figures on the move and yet
achieve a stable composition, is evidence of the highest pictorial skill
and the result of deep study. Rembrandt has looked carefully at
engravings of Raphael frescoes in the Vatican which are on about the
same scale, and something of their science underlies the whole

construction. But of course it is overlaid with the conflicting directions of gestures and pikes, and those artful contrasts of light and shade which are usually referred to as Baroque. Sometimes these devices are a bit too artful, like the butt of the gun silhouetted against the little girl (who has no business there anyway and is simply a pictorial bonus). The details are so richly painted that one looks with delight from one to another. Yes: it is a masterpiece, and I can see why it was once Rembrandt's most famous picture. I can also see why it doesn't appeal so much to us today. It is neither truth nor pageantry, and it lacks the quality that we love most in Rembrandt's work, his penetration into human character. Perhaps one trouble is the head of Captain Cocq himself: he is said to have been the stupidest man in Amsterdam and he looks it. A striking head at this central point of focus would have made a lot of difference.

At some point in the early 19th century a legend grew up that the Kloveniers Company were dissatisfied with their picture, and that some of them refused to pay their 100 guilders subscription because they were not made sufficiently prominent. This is said to have been the beginning of a decline in Rembrandt's fortunes. There is not a shred of evidence for this and lots of evidence to the contrary: for example Captain Cocq had a watercolour copy of it made for his private collection. In 1715 the vast canvas was transferred to the War Council Chamber of the Town Hall (where a bit was cut off the left-hand side to make it fit). So that by an accident Rembrandt's ambition to have a great heroic painting in a public building was ultimately achieved.

At the same period as his most ambitious composition Rembrandt began to do quite simple etchings and drawings of landscape. I suppose that he wanted to escape both from the miseries of home life and the pressure of his great commission and, like most people in that state of mind, he went for long walks in the country. In 1640 he had only to walk to the end of his street, through the Anthonies port, and in a few minutes he would have been on the Diemandyk, surrounded by lakes, canals and rushes. The first of these canal-side etchings are dated 1641 – the time of *The Night Watch*. The next year he did a view of Amsterdam [82]. How simple they all look compared to his great figure compositions of the same period. He did allow himself one dramatic landscape etching, *The Three Trees* (1643) [81], and a very moving work it is. One might have thought he would have done more etchings in the same vein: but he didn't. He continued for the next twenty years to draw the reedy canals and waterways, and abandoned cottages [80]. I suppose that their solitude gave him peace of mind, and perhaps he felt in their tumbled-down walls and roofs, which still resisted the weather, some analogy with his own stubborn determination to endure.

It may seem curious to us, who have accepted a Wordsworthian approach to nature that in his painted pictures of landscape, which

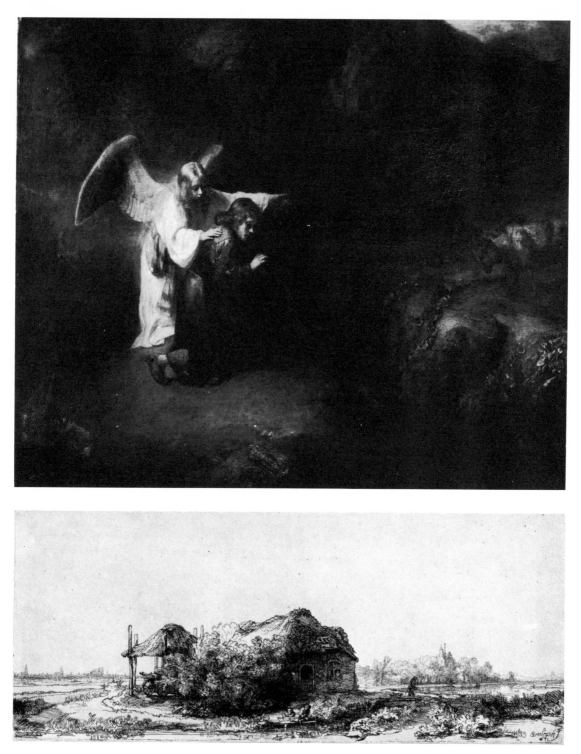

79 *The Vision of Daniel. Staatliche Museen Preussischer Kulturbesitz, Berlin Gemäldegalerie*
80 *Landscape with cottage and barn. Etching*

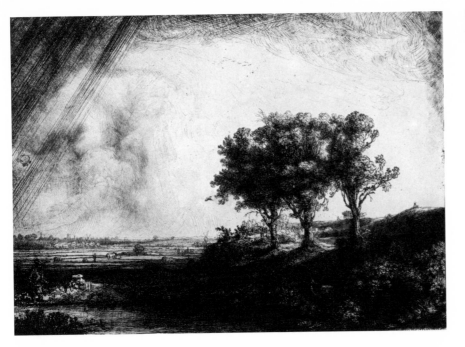

precede the naturalistic drawings by some years, he hardly makes use of direct observation at all. They are (with one exception) romantic visions done in the studio. Did he think that naturalistic landscape was beneath the dignity of art? Or was this treatment of landscape the best outlet for his deep-seated romanticism, the kind of romanticism which, for example, appears in that picture which has some of the inexplicable magic of Coleridge, *The Vision of Daniel* [79].

When a great artist like Shakespeare or Rembrandt leaves no

82 *View of Amsterdam. Etching*

The Holy Family with Angels.
Hermitage, Leningrad

written documents we tend to interpret his life through his work. Perhaps it is a mistake. But at all events, we must observe that, quite soon after the death of Saskia, Rembrandt seems to have passed into the most serene period of his whole life. His pictures of 1645 and 1646 show for the first time the sweetness of family life. There is one of them, in the Hermitage [83], for which we have a rough pen and ink sketch, and it is a good example of how an artist's mind works, because the motif that sparked him off was not the Virgin and Child, but the odd little baby angel that hovers over the cot. He was also interested in the shape of St Joseph's adze.

Another picture which gives this feeling of domestic peace and contentment is a *Holy Family* in Cassel [84], in which Rembrandt has used the curious device of painting in the frame with a curtain pulled to the side of it. Incidentally, this shows us the kind of frame that Rembrandt wanted (we see it again in a drawing of the *Preaching of St John the Baptist*), but which has proved too massive for fashionable taste, and, as far as I know,

84 *The Holy Family. Gemaldegalerie,*
Cassel

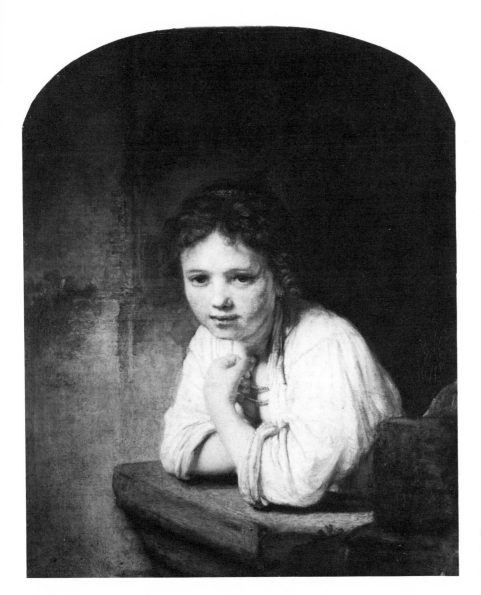

has never been attempted. The painting of a young girl, in Dulwich (not Hendrickje, who would have been twenty in 1645) radiates this same feeling of love [85], and a beautiful moonlight landscape in Dublin [86] has a lyrical feeling very rare in his work.

Among the works painted in this happy mood were two religious pictures, which can be spared from my last chapter. The first is the *Adoration of the Shepherds* in the National Gallery, London (1640) [87], wonderful not only in its disposition of light and shadow, but in the humanity with which he has invested all the onlookers. Was ever the faith and goodness of simple people more beautifully depicted? The second is the sublime picture in the Louvre of the *Supper at Emmaus*

(1648) [90]. One cannot resist comparing it with the *Supper at Emmaus* that I noticed in the preceding chapter [88]. That is one of the most striking of his early works, and is a moment of intense drama; the Apostle recognises his Master with an expression of astonishment bordering on alarm. Eighteen years later Rembrandt has lost the desire to startle. The Christ (obviously inspired by Leonardo) is not assertive but has revealed Himself humbly, as a necessary step in the fulfilment of His divine destiny. Finally, one must record that Rembrandt's greatest expression of his love for humanity, the etching [148] of *Christ Healing the Sick* (the 'Hundred Guilder Print', so called because Rembrandt himself is said to have bid that sum for it at an auction), which I describe at some length in Chapter 5, was certainly conceived, and for the most part executed, in the marvellous six years, 1642 to 1648.

This happy phase in Rembrandt's life compels us to consider a character who has been unfairly treated by Rembrandt's biographers, Geertghe Dircx. She was Titus's nurse, and probably joined Rembrandt's household in the last years of Saskia's life, say 1641. She became Rembrandt's mistress, and, since she came from Ransdorp, she, and not Hendrickje, was the woman whom Van Hoogstreten,

86 *Rest on the Flight into Egypt? National Gallery of Ireland, Dublin*

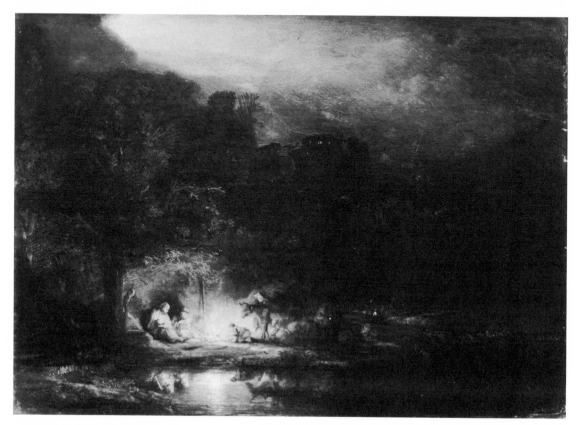

87 *Adoration of the Shepherds. National Gallery, London*

Rembrandt's pupil during the 1640s, described. 'He had as wife a little farm woman from Ransdorp, rather small of person, but well made and plump.' We do not know what she looked like. Rembrandt painted her portrait, but it is lost, and a drawing in the Pierpont Morgan Library inscribed on the back 'Geertghe Dircx' is certainly of an earlier date. Shocking as it may sound, I think that the naked woman in bed in the Edinburgh Gallery, dated 164?, may well represent Geertghe [89]. It is neither Saskia nor Hendrickje, and is too intimate in feeling to be a model. Rembrandt gave her a quantity of jewellery, including a rose ring set with diamonds and a marriage medallion. I think she must be given credit for some of the happiness evident in Rembrandt's pictures from 1642 to 1648. But the episode ended badly. In the late 1640s a

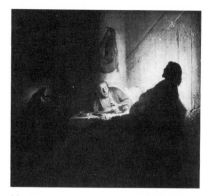

slightly younger woman joined Rembrandt's household, Hendrickje Stoffels. She was infinitely more sympathetic to Rembrandt, and was indeed one of the sweetest companions a great artist has ever had. In 1649 Geertghe sued Rembrandt for breach of promise, and in effect won her case, because, although he was not forced to marry her, he had to pay her a large sum of money and a substantial annuity. Unfortunately the victory went to Geertghe's head, and she immediately began pawning her jewellery which she had bequeathed to Titus. Rembrandt had her put into a reformatory, but she was later removed by her family, and she still appears on the list of creditors in his 'bankruptcy'. This episode evidently caused Rembrandt great distress, and for once interrupted his work. Nothing in his entire œuvre bears the date 1649. It is revealing that among the first things he did on recovering his peace of mind are the incredibly detailed etching of a shell [90a], and a number of

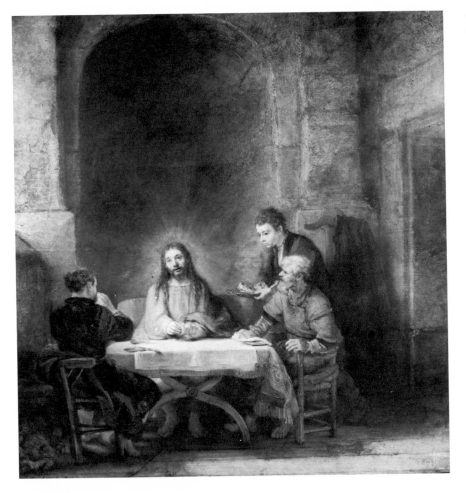

landscape-drawings. Gradually, with the help of Hendrickje, he rediscovered his true self – the man first represented in the etching of 1648, and by 1653 he could paint the first of the great series of later self-portraits [22]. But already there is a certain detachment from the world.

90a *A Shell. Etching*

91 *A man in a Cap. National Gallery, London*

The Withdrawal 4

After 1649 Rembrandt began to withdraw from his busy, successful life. It was a spiritual, not a material, withdrawal. The old writers who attributed it to adverse criticism of *The Night Watch* disregarded all the evidence. Why they supposed that Rembrandt had passed out of favour considering the long sequence of portraits, often of well-to-do people, painted in the 1650s, I cannot imagine. In addition, there were at least three important public commissions, orders from Sicily and Florence, and finally the continued popularity of his etchings, which fetched high prices at auction all over Europe. Rembrandt kept track of these sales and frequently 'bought in' a print at an extravagant price.

Yet we are right in thinking that a great change came over him, which began before 1649, as we can see by comparing the two etched portraits that I refer to in the first chapter, dated 1639 and 1648 [16 and 18]. To some extent this was due to the circumstances described at the end of the last chapter. It was also due to his happy union with Hendrickje. Under the terms of Saskia's Will he could not marry again without losing the interest on her dowry; so Hendrickje had to live with him without the blessing of the Church, which was a far more serious matter then than it is now. Hendrickje was four times summoned by the Council of the Reformed Church to be rebuked. She didn't go. She could not read or write, but signed documents with her mark. From all that we know of her and can see of her she was a completely lovable human being; but her presence meant the end of those social pretensions which had led Rembrandt to buy his far too big house. Moreover, the district had gone out of fashion, and was becoming more and more occupied by the Jews. In fact it came to be called the Judenbreestraat.

Soon after his arrival in Amsterdam Rembrandt had begun to make friends with Jews, and in 1636 had etched a portrait of the leader of the Jewish community, Simon Menasseh ben Israel, who lived in the same street [92]. This remarkable man was the teacher of Spinoza, and it seems probable that the two greatest Dutchmen met in his house or in Kostverloren, where Spinoza frequently stayed. But I cannot suppose that they would have had much in common, and do not believe in the claim put forward that a romantic portrait in Detroit represents Spinoza (indeed I doubt if it is a genuine Rembrandt). Rembrandt actually agreed to illustrate a weird, prophetic book by Menasseh called *The*

92 *Portrait of Manasseh ben Israel. Etching*

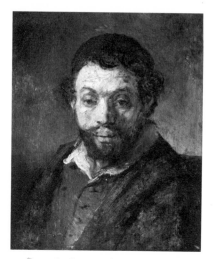

93 *Portrait of a young Jew. Staatliche Museen Preussischer Kulturbesitz, Berlin Gemäldegalerie*

Illustrious Stone, or *The Statue of Nebuchadnezzar,* in which Rembrandt allows himself almost surrealist fantasy. Later Rembrandt became a friend of a Jewish doctor named Ephraim Bueno, and left us an etching and a small portrait of him, painted with obvious affection. He had always loved painting Jews: he saw in them repositories of ancient wisdom and an unchanging faith, and found in their faces a look of melancholy, as of one who remembers a far-distant past and foresees an uncertain future – which is more than could be said of his countrymen. Some of his Jewish sitters were humble working people [93]; but the majority are superbly handsome [91], and wear their fur cloaks with a regal manner of which few of his countrymen were capable. However, he had no illusions about them, as is shown in his almost satirical etching of Jews in a synagogue [95], which, through the use of perspective, is a masterpiece of composition on two planes.

So Rembrandt changed his way of life. But it would be a mistake to suppose that he cut himself off altogether from the prosperous official world of Amsterdam. He continued to paint fashionable people; and he made one friend who was to become prominent in public life, Jan Six. Six was a rich man, whose large house in Amsterdam still stands, and he had married the daughter of Dr Tulp, so he was at the centre of the Establishment. However, he fancied himself as a poet, and wrote a poetic drama on the subject of Jason and

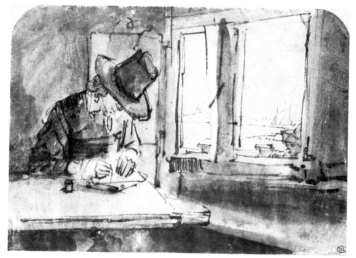

94 *Jan Six at a table. Drawing. Louvre, Paris*

95 *Jews in a synagogue. Etching*

96 *Six's Bridge. Etching*

97 *Jan Six standing, with his dog. Drawing. Six Foundation, Amsterdam*

98 *Jan Six reading. Etching*

Medea, to which Rembrandt contributed a somewhat official-looking frontispiece. It is a revealing contrast to the illustrations done for Menasseh ben Israel. In 1647 he etched a portrait of Six, for which there is a spirited drawing [97]. But when it came to the actual etching [98] his friend evidently persuaded him to dwell on the studious and poeticising aspect of his character, adopt a quieter pose and include a pile of old books. It is one of those over-finished etchings, of a kind once much admired, which have almost the quality of a mezzotint. Six had a house in the country where the atmosphere seems to have been more relaxed, and Rembrandt did some unpretentious drawings of his friend reading [94], and one of the simplest and most direct of all his etchings, known as *Six's Bridge* [96]. Towards the end of their friendship Rembrandt did a painting of Six which is perhaps the most direct and vivid of all his great portraits [99]. The surface is not fused and worked over, as it usually is in Rembrandt, but the brush strokes are sharp and clear, as if it were painted on panel (indeed I have sometimes suspected that it was originally on panel and was later transferred to canvas). Six has

99 *Portrait of Jan Six. Six Foundation, Amsterdam*

100 *The Angel leaving Tobias, 1641. Etching*

outgrown the pose of the young contemplative and has become a thoughtful man of action. But he had not abandoned his poetic ambitions, for he wrote a verse about the picture: 'Such a face had I, Jan Six, who since childhood have worshipped the Muses.'

According to the fashion of the time, he kept a family album, and in it Rembrandt did a drawing of Homer reciting his verses. It is in a far more classical style than his earlier drawings, without any of their graphic excitement. In fact the clear line is very similar to that of the Venetian Renaissance artist Carpaccio, some of whose drawings Rembrandt seems to have owned.

This is a good point to look at a change in Rembrandt's style that accompanied the change in his way of life. Baroque art is an art of engagement. The painter is involved in the emotional content of his subjects, and tries to involve the spectator by twisting movements and emphatic gestures. Withdrawal permits the more stable and enclosed design of classicism. Let me give an example, taken from two treatments of the subject of the angel leaving Tobias. It was a motif well suited to the baroque style, as one can see from an etching dated 1641 [100]. The group of figures, beautifully and variously involved, is still baroque and

101 *The Angel leaving the family of Tobias. Drawing. Pierpont Morgan Library, New York*

the angel shows the soles of his rather too rustic feet. Then, for the next twelve years, he continued to brood on the appearance of angels, and came to the same conclusion as the creators of early Christian iconography, that they must have resembled the winged victories on antique monuments. We see the result in a drawing of *The Angel leaving the Family of Tobias*, datable about 1656 [101], which is like a classical commentary on the etching of 1641. The angel is a spandrel figure from a triumphal arch. In the original he would have been draped, and would have been carrying a torch in his hands; but otherwise his pose and movement are exactly the same. The diagonal movement of this spandrel relief has dictated the design of the family group. They no longer revolve round one another, with numerous changes of axis; Tobit and his son form a severe, inward-turning triangle, geometrically related to the vertical of the door and the horizontal of Tobit's staff; and the diagonal of Tobit's back leads our eye, with almost archaic directness, to the departing angel. Thus Rembrandt has not merely borrowed an image from antique art, but has allowed it to control his whole system of composition.

Where did Rembrandt acquire his knowledge of classic art? Chiefly

102 *Copy after Mantegna's drawing 'The Calumny of Apelles'. Drawing. British Museum, London*

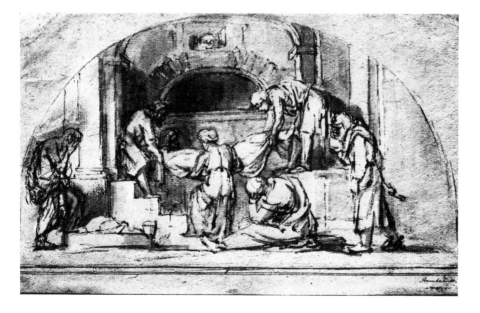

103 *Entombment, after Polidoro da Caravaggio. Drawing. Teylers Stichting, Haarlem*

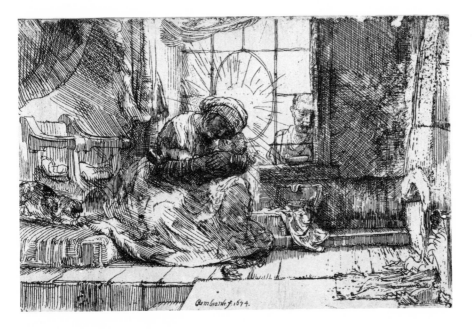

from engravings, both of antique reliefs and High Renaissance figure compositions. His inventory mentions six portfolios of engravings after Raphael alone. The most intriguing item it contains is called 'The precious Book of Andrea Mantegna'. Mantegna, on account of his rigorous classicism, had never fallen out of favour as other 15th-century Italians had done. When the Parliamentarians sold Charles I's collection, Mantegna's *Triumph of Caesar* was retained, it is said, on Cromwell's instructions. So Rembrandt's 'precious Book' was a source of inspiration as well as a treasure. It contained one of Mantegna's most famous drawings, *The Calumny of Apelles*, of which Rembrandt made a careful copy (copying even Mantegna's writing) [102], although he does allow himself some touches of his own shorthand. The 'precious Book' certainly contained two of Mantegna's engravings, the *Virgin and Child* [105], a design so complete that Rembrandt did not want to vary the pose, only to put the Virgin into contemporary dress and set her in her room, with Joseph looking in through the window [104]; and *The Entombment*, of which he

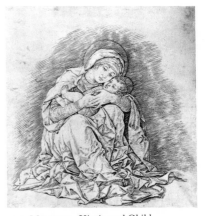

105 *Mantegna. Virgin and Child. Engraving*

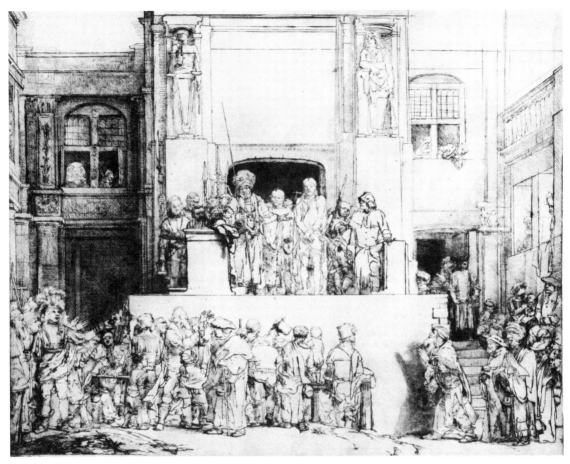

106 *Christ Presented to the People. Etching, first state*

made a fairly close copy, but characteristically left out all the decorative twirls of drapery, which was the 15th-century convention, but offended against Rembrandt's sense of truth. The Mantegna Album may also have contained a drawing related to his sublime painting of the dead Christ in foreshortening for, as we shall see, this figure was to be the centre of one of Rembrandt's greatest compositions.

Usually the study that Rembrandt made of these Renaissance models was so completely absorbed into his own style, that we should never be aware of it if the original copy had not survived. He made a copy of a drawing by a pupil of Raphael named Polidoro Caravaggio [103], and one can hardly imagine a more dogmatically classic design, the figures parallel with the picture plane bounded by an inner and outer arc. By various stages the discipline loosened its grip till the classic construction becomes this perfectly natural and spontaneous-looking etching of the Entombment.

The grandest and most austere of Rembrandt's compositions in the

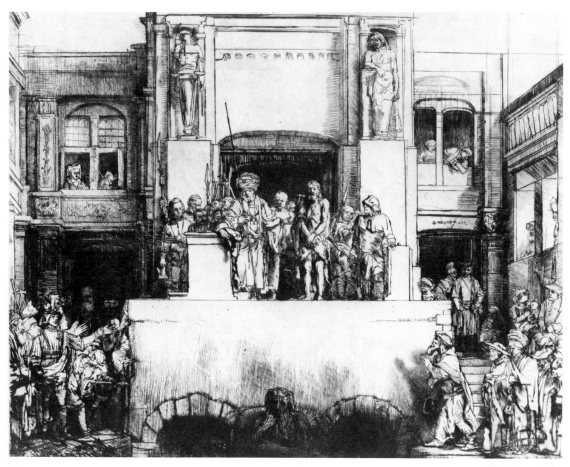

High Renaissance manner is his etching, *Christ Presented to the People* (1655) [106] and one cannot help wondering whether, in choosing this subject, Rembrandt did not consciously set himself to show how splendidly he had mastered the laws of design since the time of the early version, which I compared to an animated molehill. He was the more anxious to do so because at this time Dutch patrons were engaged in planning various schemes of decorative painting. From these projects Rembrandt was generally excluded, and the commissions given to complete nonentities. This great etching was Rembrandt's answer – a proof that he could have executed monumental painting equal to that of the Renaissance.

The basic idea is a contrast between the frontal, implacable architecture, symbolising the rule of justice, and swarming, disordered humanity – the public. Christ and the High Priest are presented on a higher plane and, as it were, more rigidly encased in their abstract setting. Compared to the earlier version the literary content is of

secondary importance: of course anything that Rembrandt does is crammed with humanity, but the Dickensian mixture of satire and sentiment has vanished. There are no indignant priests, and most of the crowd are watching this crucial moment in human history as if it were a street accident. Only one old man on the right seems to be genuinely moved. The High Priest is a dignified character, not without a certain pathos, as of one who willingly fulfils his destiny. Christ views the scene with a strange detachment, and makes no direct appeal to our emotions. This contrast between the milling crowd below and the solemn party on the platform was abandoned in a later state of the etching [107], when Rembrandt made one of the most drastic changes ever inflicted on a work of art. The crowd, shoving and gesticulating round the base of the podium, is removed, save for two figures peering anxiously round

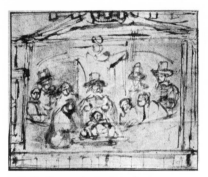

108 *Dr Deyman's Anatomy Lesson. Drawing. Rijksmuseum, Amsterdam*

109 *Dr Deyman's Anatomy Lesson. Rijksmuseum, Amsterdam*

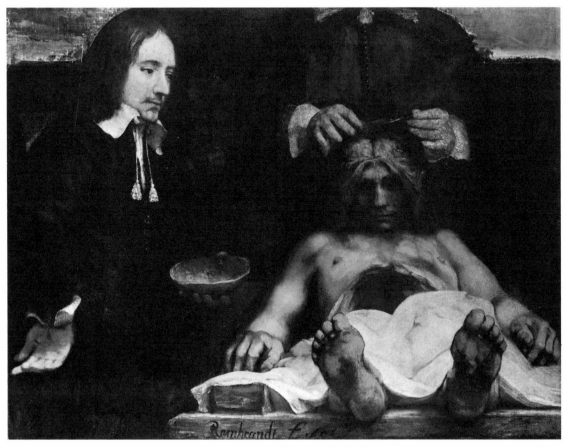

the corners; and in its place appear two arches, shaggy, rusticated, irregular, the greatest possible contrast to the trim abstraction of the earlier design. They are like the doors of a Piranesian dungeon, or conduits leading to some *cloaca maxima* – orifices through which we enter those portions of human economy which lie hidden from our consciousness. Between these arches, in a few rare impressions, is a shadowy figure, whose flowing beard and braided hair are those of an antique river god, and who rests his arm on a pitcher; but his pensive pose is unmistakably Michelangelesque. A powerful intellectual construction is sacrificed to an imperative dream.

In the following year, 1656, Rembrandt received from the Anatomy Theatre a commission to do another, and much larger, painting of a

dissection; this time by Dr Joan Deyman, who had succeeded Dr Tulp as head of the medical school [109]. The two pictures hung together in the Anatomy Theatre and, for those with eyes to see, must have been a moving demonstration of how Rembrandt's art, over twenty years, had gained in depth.

To our eternal loss *Dr Deyman's Anatomony Lesson* was burned in a fire, but a fragment was recovered (in Cheltenham, of all unlikely places), and is now in the Rijksmuseum. Fortunately Rembrandt had made one of his small drawings to show how the picture should be framed, and from this we can try, imaginatively, to reconstruct the original [108].

This was Dr Deyman's first dissection of a corpse, and a solemn moment in his career. Rembrandt has therefore based his design on a most awe-inspiring figure – the dead Christ in Mantegna's great picture in the Brera*, and he has given the head an expression of living pathos – the head of a god of human sacrifice. Involuntarily we look for stigmata on hands and feet. As far as we can judge from the diagrammatic drawing, the whole picture was conceived in these almost sacramental terms. Dr Deyman rose behind the corpse like the celebrant of some religious rite, and his assistant, fortunately preserved, has the solicitude of an acolyte. Behind him the spectators sit and stand as if in the apse of a church, and even the undecipherable object above Dr Deyman's head reminds us of a crucifix.

In the years when these two great works were executed, with superb intellectual power, as well as pictorial skill, the confused state of Rembrandt's finances reached a climax. It is hard to say why he fell so deeply into debt: what with his own earnings and Saskia's dowry and his fifty pupils, he could have been perfectly solvent. I suppose that the depression of the Dutch economy in 1654 may have had something to do with it, and there is some evidence that he speculated in the East Indian market. But far more relevant was Rembrandt's glorious prodigality. He bought antique busts in competition with really rich men, and we see how he used one of them in his famous picture *Aristotle contemplating a bust of Homer* [110]. He spent large sums bidding at auctions and, in spite of all his earnings, he failed to pay back the money advanced to him for the purchase of his far too large house. Inevitably some of his creditors, who had behaved with the utmost tolerance, became a trifle restless, and in order to pay them off Rembrandt began to borrow more money, quite large sums, from his friends, including Jan Six. He could have been made a bankrupt, but the court very humanely decided on a 'surrender of goods'. This meant that he had to part with

*There are several copies of Mantegna's picture, and there may well have been a drawing for it in the 'precious Book'. In view of Rembrandt's deep admiration for Mantegna a recent suggestion that he took the figure from a picture by Orazio Borghianini in the Gallerie Spada does not convince me.

his collection, and in 1656 it was catalogued for sale. The Inventory exists, and is a fascinating document, as it shows us exactly what Rembrandt had collected in the preceding twenty-five years. I have already mentioned the gold helmets, the Japanese armour, the weapons, the rich draperies; the drawings and engravings. In addition, there were paintings by many of the leading Dutch artists of the time – in particular Hercules Seghers, Brouwer and his old associate Lievens; and of course many pictures and portfolios of drawings by Rembrandt himself. It is

111 *Portrait of Jacob Haaring. Etching*

112 *Woman bathing. National Gallery, London*

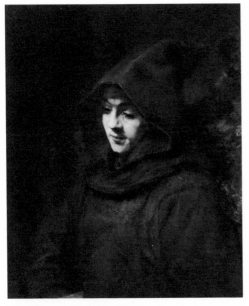

113 *Titus as a Capuchin Monk.*
Rijksmuseum, Amsterdam

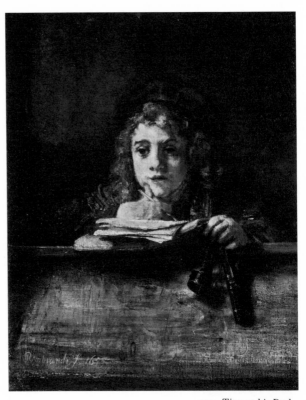

114 *Titus at his Desk,*
1655. Museum
Boymans-van
Beuningen, Rotterdam

usually supposed that the sale of all these precious possessions was a great blow to him. But who can tell? There is a point at which possessions become a burden: they are exhilarating to buy, but a nuisance to look after. What if moth had got into the fur caps, and the Japanese armour had rusted, and pupils had spilt turpentine on his Marcantonio engravings and poisoned his pet monkey (which one of them actually did). Great artists are not always sorry to become anonymous: Turner's grumpy isolation, Hokusai's profession of madness, even Mozart's pauper's grave, were not as pathetic as they seem. Rembrandt's etchings show him to have been on excellent terms with his creditors. Only Six swam upwards, out of sight. One of his most sympathetic portrait-etchings is of the actual Bailiff of the Court of Insolvency, Jacob Haaring [111]. As we have seen, the grandest and calmest of all his self-portraits [24] was done in the year of his sale. The only institution that behaved badly to him was, predictably, his own Union, the Guild of St Luke: it brought in a special clause that any member who had been sold up could under no circumstances be allowed to carry on trade. He was saved by Hendrickje and Titus, who formed themselves into a company, sold all his work and gave him free board and lodgings.

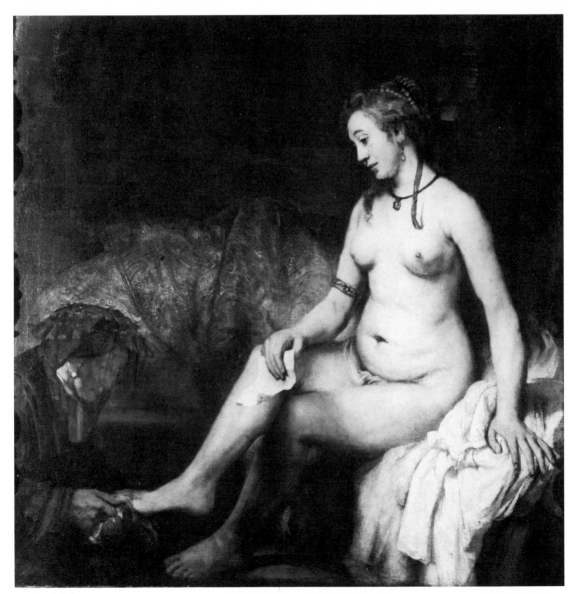

115 *Bathsheba.*
Louvre, Paris

It is now time to return to these two companions to whose love and loyalty the world is so deeply indebted. We know Titus at every age. We see him as a small boy, puzzling over his lessons, on one of Rembrandt's most exquisitely painted pictures [114]. That hand and thumb pressed against the chin is an example of delicate observation and plastic colour, which even Rembrandt never surpassed. We see him sitting at his desk, either writing or drawing (for he became a not very skilful artist, and a picture of two little dogs by him is included in the Inventory); he is the

model for Isaac in an etching; we see him growing to manhood and, most beautiful of all, we see him in the habit of a monk [113]. Finally comes the portrait at Dulwich, which must have been done shortly before his marriage.

As for Hendrickje, she is represented in a variety of subjects, from the study of her paddling in a stream [112]. painted with the same direct strokes as the Six portrait of the same year, but actually on panel; to the portraits in which he gives his small, plump companion an almost Titianesque grandeur. He has no sentimental scruples about portraying her in the same role as Saskia – a sort of spring goddess; but he does it so much more simply. Above all, she is the subject of one of his greatest pictures, the *Bathsheba* in the Louvre [115].

Most people looking at this picture think first of the expression on Bathsheba's face as she ponders the

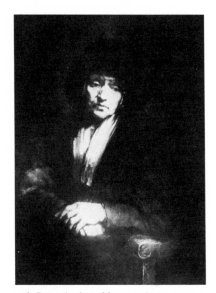

116 *Portrait of an old woman in an arm chair. Hermitage, Leningrad*

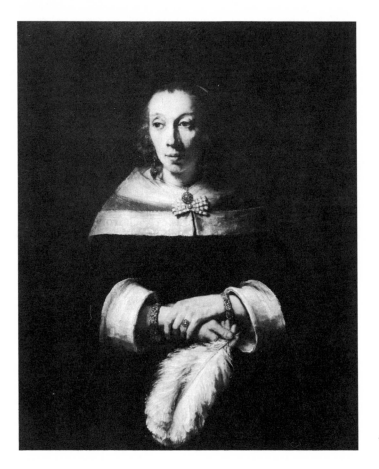

117 *Portrait of a lady with an ostrich feather. National Gallery of Art, Washington*

contents of David's letter. The depth and subtlety with which he has rendered her emotions have never been surpassed. Then one looks at the unflinching modelling of her round, solid body, which is seen with such love that it becomes beautiful. And only after this do we think about the whole design, and realise how perfectly balanced it is, and how admirably the figure is related to the space. It has recently been shown that Rembrandt evolved this design by a coalition of two engravings of antique reliefs. It is the supreme example of how his study of classic art

does not deflect him from his search for truth.

This was the period of Rembrandt's finest portraits. For sheer mastery of design he never excelled the lady with an ostrich-feather fan from the Yousupov Collection [117]. It is significant that, whereas the great portraits of the 1630s and 1640s were chiefly of men – preachers, evangelists, fellow craftsmen – the most moving portraits of the 1650s are of women. Warmth, sympathy and insight had come to mean more to him. Most of them are of elderly ladies, like the one with the life-battered old face in the Hermitage [116]. They culminate in the two portraits of Mrs Tripp in the National Gallery, London, which, hanging in the same room, provide a moving exposition of Rembrandt's approach to portraiture [118 and 119]. They are, so to say, her private

119 *Portrait of Mrs Tripp. National Gallery, London*

120 *The Syndics. Rijksmuseum, Amsterdam*

121 *Study for a standing Syndic. Museum Boymans-van Beuningen, Rotterdam*

and her public likeness. The private likeness discloses a latent wit and even a trace of coquetry: we can see that she was once a pretty girl. The public likeness is solemn, frontal and monumental, and the head, constructed with great severity, denotes the sorrows of a long life. Both are miracles of sheer painting. Sargent said that he usually knew how things had been done, but that the head of Mrs Tripp defeated him. Perhaps the answer is that every delicate flick of colour was put on after the rest of the paint surface had dried. She must have been a very patient old lady. He also painted a portrait of her husband, a noble-looking old man in a fanciful robe. One could not have guessed that he was a rich armament-manufacturer, who sold arms to both sides in the English Civil War.

In front of these marvellous heads we cannot help lamenting the fact that portrait-painting has temporarily ceased to be a possible means of creation; for, although the idea has not commended itself to theorists,

the fact remains that some of the greatest of all works of art consist simply in the representation of a face. I said 'temporarily', and I hope that this is true: for our present decline in portrait-painting may be partly due to confusion with those commercial artefacts which satisfy a social or official requirement. But if the decline of individual likenesses is symptomatic of a general stamping out of the individual, then the world will have to wait many centuries before seeing again a touching perpetuation of a human spirit like the head of Mrs Tripp.

The most famous of these late portrait commissions is the group known as *The Syndics* [120]. It represents the five Staalmeesters of the Cloth Hall of Amsterdam for 1661–2, and is another proof that Rembrandt was neither forgotten nor neglected. What a contrast are the six men in this quiet room to all the display and bustle in the sortie of Captain Cocq's Company. *The Syndics* is one of those great classic works of art in which the vision seems so simple, the composition so final and so inevitable that we are at first inclined to take it for granted. But the more we study the composition, the more we recognise the perfect sense of rhythm with which our eye is led into the main subject of interest. First the placid figure on the right, then an interval, then the closely worked out pyramidal group, which, nevertheless, by the direction of the hat brim and the regard of the left-hand man, leads us on to the Staalmeester, bending over his colleague to look at some reference in a book. If the man on the left of the pyramid had been looking straight at us, instead of up to the left, he would have closed the group, and prevented our eye travelling on to the standing Syndic. This man is the corner-stone of the composition, and it is proof of Rembrandt's skill that we are not disturbed by his arrested pose. In fact Rembrandt originally drew him standing upright, but realised that this raised him too much outside the design [121]. Another study, in the shattered, reckless style of Rembrandt's latest drawings, shows how at one time he had thought of bridging the interval by making the seated man look up at the standing one, but this in its turn created new complications of focus. And so at last he arrives at the solution that dominates the Rembrandt Room in the Rijksmuseum. It is the end of the long discipline which began when Rembrandt made his first copies of Leonardo's *Last Supper*, and in fact the man half rising is inspired by the St Bartholomeo in Leonardo's masterpiece. But these and many similar devices of pictorial architecture become apparent to us only when we, so to say, take the picture to pieces and put it together again. Our first impression is one of perfect naturalism and truth.

The Syndics is quietly painted. Unless we examine one of the heads closely we are hardly aware of the paint surface. All his life, it seems to me, Rembrandt used to paint for two different purposes. One cannot exactly call them poetry and prose, but one can see a striking difference

122 *Lucretia (1666).*
Minneapolis Institute
of Art

123 *Lucretia (1664).*
National Gallery of
Art, Washington

between the pictures in which the paint seems to speak to us in its own right and heighten our emotions by its rich language, and those in which, however subtly and perceptively, it is used to record visual experience. An example is the beautiful, androgynous figure in armour [126], of which the subject and even the sex has been questioned. The helmet, with its owl of Minerva, is a child of Rembrandt's imagination, completely re-created in paint, and perhaps should not be taken seriously as iconographical evidence. This may even be the *Alexander the Great* commissioned by Antonio Ruffo, Rembrandt's patron in Messina, for whom he also did the *Aristotle contemplating a bust of Homer*. The face is the face of Titus. Two other instances of colour and jewel-like pigment used to stir our emotions are the two pictures of Lucretia, painted in the last years of his life [122 and 123]. I have said several times that to relate Rembrandt's art to the facts of his life leads to bewilderment: the most humanly sympathetic of men, when he took up his brush passed out of everyday life into a world of the imagination. The two Lucretias are the most baffling instances of this transcendence, because they were done in the years after the death of the beloved Hendrickje. There can be no question of a sense of liberation as there is in the *Danaë*, and in the happy pictures painted after the death of Saskia. What can have made Rembrandt choose the subject at all: nothing in his drawings and etchings gives us a clue. One must not try to interpret, but only abandon oneself to the piercing beauty of colour and sentiment in these two evocations of the sensuous ecstasy of death. The picture in

which Lucretia stabs herself reminds me of Bernini's *Sta Teresa*; in the second scene the deed has been done, and with her other hand she pulls a cord for the curtain to fall.

This use of paint to stir our feelings is not necessarily connected with physical beauty and rich ornament. It is in fact the means by which one of Rembrandt's most extraordinary and moving works makes its effect on us: *The Slaughtered Ox* [124]. Critics used to quote this picture to

124 *The Slaughtered Ox. Louvre, Paris*

125 *The Jewish Bride.*
Rijksmuseum,
Amsterdam

prove that subject didn't matter in painting – incredible! – because this is a subject which at one time or another has shocked nearly all of us: there can be few people who have never felt a twinge of horror and pity in passing a butcher's shop. Actually there is a little drawing by Rembrandt which seems to record this experience, in which the grand, pitiable carcass is seen at night, through the open door of the shop, with ghoulish little figures peering round its base. Rembrandt has maintained the intensity of this first moment of vision in his picture, and has added to it by the marvellous painting of all the details, many of which themselves set off new trains of association. The flayed ox has become a tragic – one might almost say a religious picture.

The supreme example of Rembrandt's use of paint to lift a subject on to a different plane, as language may lift a commonplace sentiment to the level of the highest poetry, is the picture known as *The Jewish Bride* [125]. When did the picture first acquire this title, which seems to have as little relevance as *The Night Watch*? It has set scholars off in search of Old Testament stories, and they have usually closed for Isaac and Rebecca, of whom Rembrandt had, much earlier, made a hasty

drawing, based on a fresco in Raphael's Loggie. But to argue over the picture's title is frivolous: as in all the greatest poetry, the myth, the form and the incident are one. Rembrandt saw any loving couple, long sought and wholly devoted, as Isaac and Rebecca, and whether or not the position of their hands is that of a Jewish betrothal, it is an ancient and satisfying symbol of union, which, through the magic of Rembrandt's transforming touch, has become one of the most moving areas of paint in the world. *The Jewish Bride* is the climax of Rembrandt's lifelong struggle to combine the particular and the universal, and he has achieved his aim in two ways: by relating accidents of gesture to the deep-rooted recurring motives of Mediterranean art; and by seeing episodes in actual life as if they were part of the Old Testament. It is this last endowment which made him an interpreter of the Bible, so unpredictable, so enlightening, and so profound that I must make Rembrandt and the Bible the subject of a separate chapter.

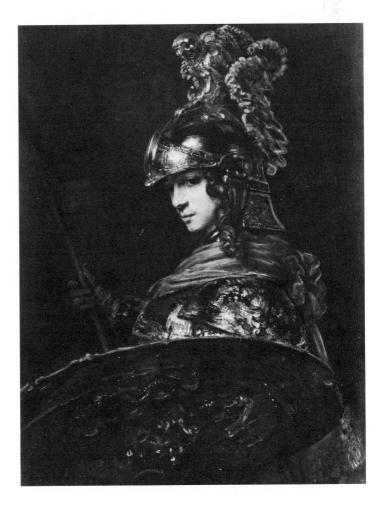

126 *Pallas Athene. Calouste Gulbenkian Foundation, Lisbon*

127 *The Annunciation. Musée Communal, Besançon*

Rembrandt and the Bible

Protestantism, like Islam, was a religion of the word and the chant, not of the visual image, and for a century after the first translation of the Bible there was no Protestant visual art. Cranach happened to work for a Protestant patron but there is nothing of Calvin in his sinuous beauties. 'The Word' meant the Bible. It is difficult for a Protestant to realise how far this had become a closed book, to a Catholic not only closed, but prohibited. George Borrow was imprisoned for selling bibles in Spain. Even today some Catholic historians have not read the Old Testament. Rembrandt, as I have said, was brought up on the Bible: a picture of his mother by his pupil, Gerard Dou, shows her reading it and traces on the canvas the actual page of the Gospel according to St Luke.

There is some evidence that she was brought up as a Catholic, but by the time of Rembrandt's youth had become an earnest Protestant. G. K. Chesterton said that the trouble with Protestants was not that every man read *the* Bible, but that every man read *his* Bible – that is exactly what Rembrandt did. He no doubt discussed the meaning of many passages with the preachers and scholars whose portraits he painted: also with sectarians like the Mennonite Anslo; and notably with the Jews. But in the end the Bible he illustrated was *his* Bible, that part of Holy Writ which supported his own convictions, those episodes that illustrated his own feelings about human life and of the Divine intervention on which it depended.

At this point I should perhaps say a few words about the state of religion in Holland. After the Synod of Dort there was supposed to be complete toleration for any non-Catholic belief. In fact the Calvinists split in two. The strict Calvinists became the official church, and attached themselves to the Head of State; the more easy-going Calvinists, called Arminian Remonstrants, attached themselves to what was called the Regent's Party, which was republican. The religious-political feud between these two parties was extremely bitter, and led to atrocities; but it does not seem to have affected Rembrandt in the least. His first major commission, the scenes of the Passion, was given to him on behalf of Prince Frederick Henry of Orange, head of the official Calvinist party, and the pictures look indistinguishable from Catholic painting; but most of his sitters, both preachers and merchants, were

128 *Abraham entertaining the angels.*
Etching

129 *Homer dictating to a scribe.*
Mauritshuis, The Hague

Arminian Remonstrants, and he himself was drawn to the dissenting sect of the Mennonites. We do not know of a single case in which one of his paintings or etchings was denounced as heretical in the religious sense – only in the artistic.

Considering the vast number of subjects in the Bible that Rembrandt illustrated, it is interesting to notice those that had no appeal to him. For example, there is not a single illustration of the Book of Job, although one might have expected it to be full of Rembrandtesque motives. He never attempted the Last Supper, and there is only one drawing of the Annunciation [127], and what a drawing – so full of delicate, subtle human feeling, as opposed to the formalised acquiescence of the 16th century. For him the Virgin is always a human and not a symbolic figure, and St Joseph occupies the foreground, in a way he never does in Catholic art. 'Suffer the little children to come unto me': considering how much Rembrandt loved drawing toddlers, this subject would seem inevitable. But he left it to Nicholas Maes.

Looking at his etchings, and above all at his drawings, to discover what elements in the Bible meant most to him, I think first of all of those moments of conjunction of the human and the divine, when simple people realised that they had been accompanied and directed by a higher power. The etching of Abraham entertaining the angels [128] is like an illustration of a beautiful poem by Henry Vaughan, written in Rembrandt's lifetime:

> My God, when I walk in those groves
> And leaves thy spirit still dost fan,
> I see in each shade that there grows
> An Angel talking with a man.
>
> In Abraham's tent the wingèd guests
> (Oh how familiar then was Heaven)
> Eat, drink, discourse, sit down and rest
> Until the cool and shady even.

Abraham, Manoah, Tobit and, I suppose one may add, the Supper at Emmaus, these were favourite subjects. Sometimes these divine moments are conveyed in a single sentence: 'and she took him for the gardener' [130]; sometimes they seem almost accidental; sometimes they are the essence of the legend. Of these stories of angelic guidance the one which supplied

Rembrandt with most themes was the Book of Tobit. In our Bible it is banished to the Apocrypha – and quite rightly, as it is a Persian folk-tale, unconnected with the spiritual history of the Jewish people; but it was included in the Dutch Bible, and Rembrandt loved it, not only because of its wealth of picturesque incident, but because it is concerned with angelic guidance.

It begins when Tobit is asleep and swallows drop dung into his eyes, thus making him blind. This was a theme very near to Rembrandt's heart, for the man, in whom the optic nerve must have been as quick and sensitive as in any human being since Leonardo da Vinci, was constantly haunted by the thought of blindness. How often the head of blind Homer, based on an antique bust, reappears in his work [129], and

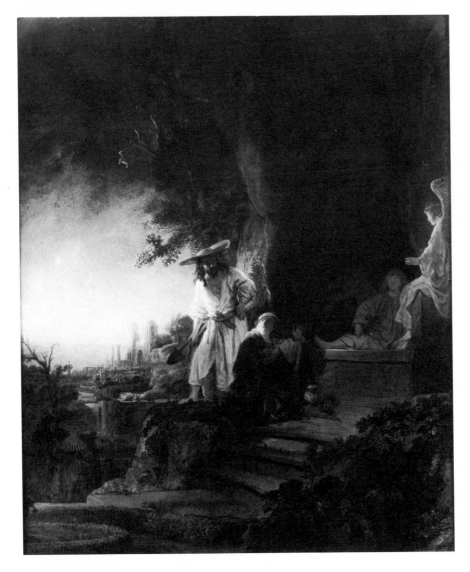

130 *The Risen Christ appearing to the Magdalen. Royal Collection, reproduced by gracious permission of Her Majesty the Queen*

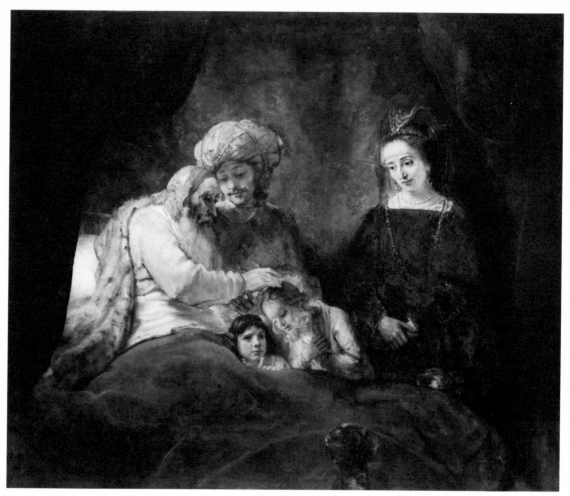

131 *Jacob blessing the children of Joseph. Gemäldegalerie, Cassel*

was in fact the subject of his last picture; and how many of his illustrations to the Bible represent blind men, like this head of Jacob blessing the children of Joseph [131].

Tobit's blindness is the subject of one of Rembrandt's most moving etchings: it is the quintessence of blindness [133]. He knocks over the spinning-wheel and stumbles against his little dog. Brooding on his misfortunes, he picks a quarrel with his old wife, Anna, accusing her of stealing a kid. This is the subject of the very earliest picture in which Rembrandt gives evidence of his exceptional talent [132], and the Anna is in fact a portrait of his mother; the real motive is blindness. Tobit then remembers a debt that is owed to him by a man who lives in the distant country of the Medes, and decides to send his young son, Tobias, to collect it. Tobias does not know why, but he is joined by a companion, who is in fact the Archangel Raphael. Tobit sees them off, with much lamentation from his wife, Anna. The little dog goes with them.

This, incidentally, confirms the Persian origin of the story, as dogs were considered unclean in Israel, and Tobit's dog is actually omitted from the Hebraic version, although included in the Vulgate. Tobias goes down to bathe in the Tigris, and is attacked by a huge fish, but his companion helps him to kill it, and advises him to take out the heart, liver and gall. He finds the debtor, collects the money, and marries his daughter, after burning the fish's liver, which successfully overcomes an evil spirit. The couple then return, all is peace and joy, and with an ointment made from the fish's gall he cures his father's blindness. Rembrandt depicts this episode several times, but he cannot help thinking that what was really the matter was cataract (the Dutch translation, like the English, used the word 'whiteness'), and in one or two of his drawings he runs counter to the legend, and shows an operation for cataract taking place. Then, when everything is arranged, comes the moment

132 *Anna accused by Tobit of stealing a kid. Rijksmuseum, Amsterdam*

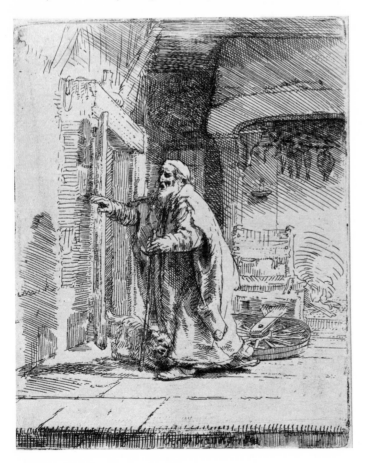

133 *The blindness of Tobit. Etching*

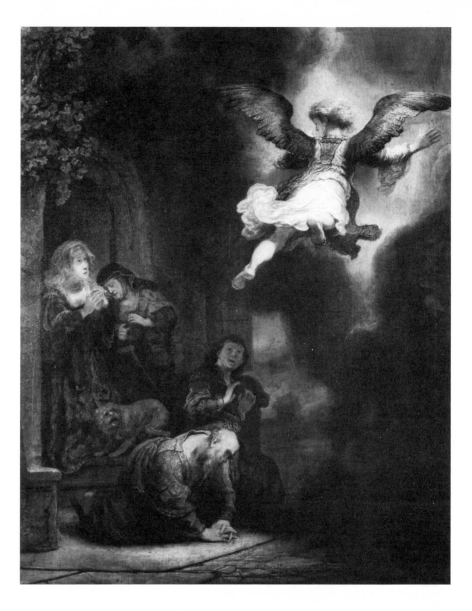

134 *The Angel leaving Tobit. Louvre, Paris*

which Rembrandt loved best in all Bible stories, the moment when Tobias's companion reveals his true status, and swishes up into the sky, leaving the united family (the dog still very much in evidence) prostrate, astonished and adoring [134].

What these moments of angelic revelation meant to Rembrandt is evident from the number of times he returned to the biblically not very important story of Manoah, the father of Samson, whose birth was announced by an angel. He treats the subject in a series of magnificent drawings [135]. It is known from a picture in Dresden [136], dated 1641; but for various technical reasons I don't think the beautiful

picture can be of that date because Rembrandt's drawings related to it are all far later. The drawings of the same date are still baroque; those that resemble the picture most belong to the late 1650s. It is an example of the anti-baroque as clear as the one of the angel departing from Tobit. However, we need not concern ourselves with such problems, and notice only how deeply he felt the moment at which ordinary mortals suddenly realised that there had been a divine presence among them. The most dramatic of all angelic interventions was, of course, the sacrifice of Isaac [139], what one might, without levity, call a very close run thing. The angel is only just in time to cause Abraham to drop his knife. Stylistically it is interesting to compare the

135 *Angel announcing the birth of Samson to Manoah. Drawing. National Museum, Stockholm*

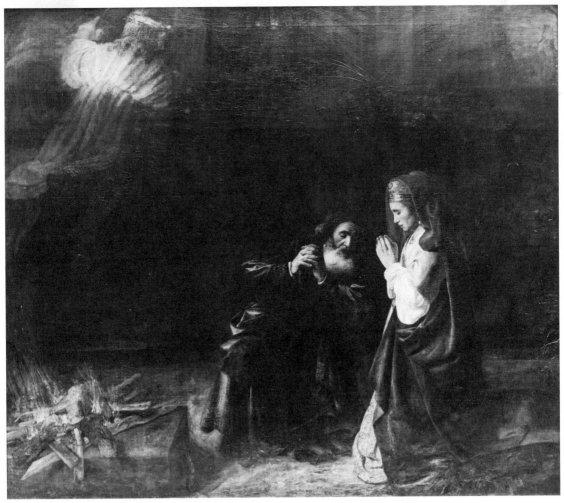

136 *Manoah's offering. Staatliche Kunstsammlungen, Dresden*

drawing for this picture with the etching of the same subject done twenty years later [137 and 138]. Instead of the rich, dark rotundities of Rembrandt's baroque style, there are sharply contrasted diagonals, forming a closely knit design. The scene gains an added poignancy from the fact that even from the upper part of his face we can see that the Isaac represents Titus.

One of Rembrandt's greatest drawings shows the moment when God announces his Covenant with Abraham [140]. In a few rough diagonal strokes he gives the essence of this moment, which was to be decisive alike for Islam as for Judaism. I can think of few works of art in which the terrifying majesty of God's presence is

137 *The sacrifice of Isaac. Drawing. British Museum, London*

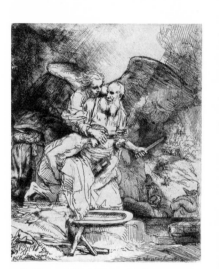

138 *The sacrifice of Isaac. Etching*

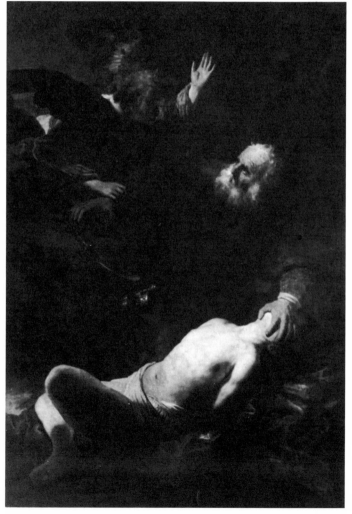

139 *The sacrifice of Isaac. Hermitage, Leningrad*

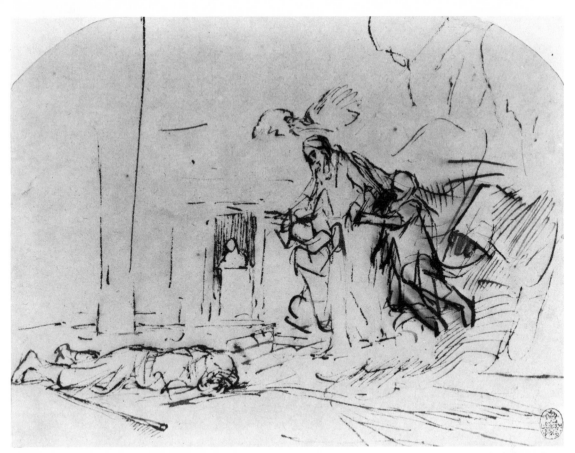

140 *God announcing
his covenant to
Abraham. Drawing.
Staatliche
Kunstsammlungen,
Dresden*

more powerfully conveyed.

Dramatically, the most effective of these revelation drawings is the
Supper at Emmaus in which Christ, having been recognised by the
Apostles, vanished from them in a blinding flash of light [141]. Some
scholars have doubted if this moving sheet was drawn by Rembrandt's
own hand: and, since drawings play so great a part in this chapter, I
ought perhaps to say a word about the problem of their authenticity. It
is one of the most delicate in the whole history of art, the reason being
that for over thirty years Rembrandt had a large number of pupils –
sometimes as many as fifty – and they included nearly all the most gifted
young painters in Holland. He not only taught them but he inspired
them. They made copies of his drawings which are almost indis-
tinguishable from the originals; they took unfinished drawings that he
had thrown away, and worked them up – as in the Tobit series [142],
where I think that the right-hand Tobit is authentic, and the rest added
by a pupil to make a saleable drawing.

Every scholar who writes about Rembrandt's drawings makes a

141 *The Supper at Emmaus. Drawing.*
Fitzwilliam Museum, Cambridge

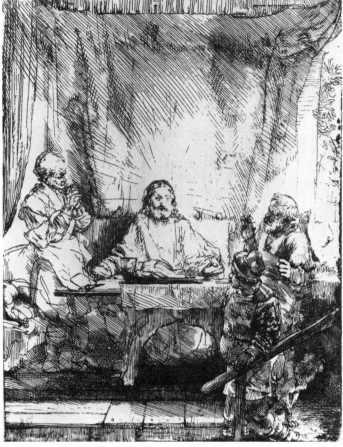

144 *The supper at Emmaus, 1654. Etching*

142 *The return of Tobias. Staatliche*
Museen Preussischer Kulturbesitz, Berlin
Kupferstichkabinett

143 *The return of the Prodigal Son.*
Groningen Museum

somewhat different choice, and to my mind they all include drawings that are manifestly wrong. How can a scholar as judicious as Dr Haak have included a drawing like [143] and several others by the same hand, in which the scrawls show no underlying knowledge of structure? But then there is no means of proof. One must simply immerse oneself in the drawings for months on end, till one feels, perhaps mistakenly, that one is in a state of grace.

So, to return to the *Supper at Emmaus*, a drawing which I have known in the original since I was a boy: at the moment I am inclined to think it authentic, but if the Archangel Raphael told me it was a copy, I should not be surprised. It is, for one thing, difficult to date: always a danger sign in deciding the authenticity of a work of art.

145 *Joseph's brothers persuading their father to let Benjamin go to Egypt. Drawing. Rijksmuseum, Amsterdam*

The squarish facture suggests the 1650s; but can it really be of the same date as the quiet etching of the subject [144], which is, so to say, steeped in truth, and is dated 1654?

Well, these may seem like mere technicalities, but we cannot follow Rembrandt's development and the movement of his mind without paying attention to them.

Although Rembrandt enjoyed vivid story-telling in the Bible, it is interesting to see how he chooses those parts of a narrative that have a supernatural element. No story in the Old Testament is more full of drama than that of Joseph, but the incidents he depicts most often are those in which Joseph tells his prophetic dreams, either to his brothers or to his fellow prisoners. Curiously enough he seems never to have drawn the culminating episode in the story, where Joseph reveals his identity to his brothers; one of the most moving passages in the Old Testament. Instead he did a magnificent drawing of Joseph's brothers

146 *Peter praying for Tabitha. Drawing.*
Musée Bonnat, Bayonne

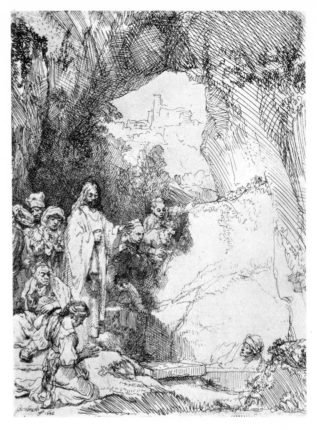

147 *The raising of Lazarus, 1641. Etching*

persuading their father to send Benjamin back with them to Egypt [145]. It is like a page in a great novel, every head showing a profound insight into human nature. Incidentally, the figures on the left are a proof that Rembrandt was familiar with the drawings of Leonardo da Vinci: it happens that the whole volume of Leonardo's drawings which now forms the Windsor Castle Collection, was then in Amsterdam, the property of Lady Arundel, and one cannot help wondering if Rembrandt saw it. I incline to think not, or the borrowings would have been more extensive. But some of the grotesque heads, then so popular, and often copied, he evidently had seen.

Since Rembrandt feels that a divine element is always close to us in our lives he is particularly fond of portraying miracles. His early miracles are dramatic events. The large etching of the *Raising of Lazarus* done in 1631 is too obviously impressive; but as Rembrandt came more and more to relate his Bible-reading to the life around him, this element of artificiality dropped away. Nothing could be simpler and more modest than the *Raising of Lazarus* done only ten years later [147].

One can say that with time Rembrandt's interpretation of the Bible came to be almost indistinguishable from his response to the life around

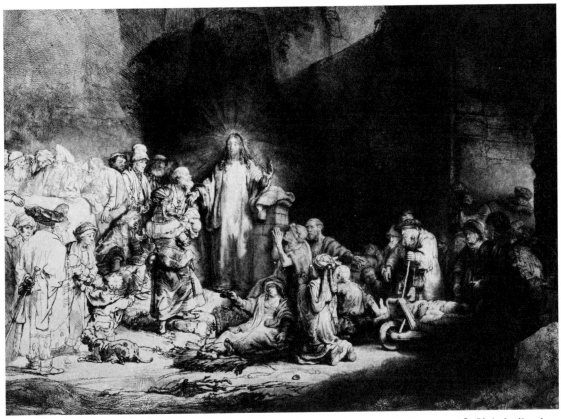

him. Did he do the drawing on plate [146] as an illustration of Peter praying for the revival of Tabitha; or had he seen a pious old neighbour praying for the recovery of his sick wife? It is interesting to see how many of the miracles depicted in his drawings are those performed by the Apostles. There are, of course, magnificent exceptions, and Rembrandt is particularly fond of the raising of Jairus's daughter – 'She is not dead, but sleepeth.' During his middle years all his thoughts about Christ's miracle-working powers contributed to one of the most deeply felt and carefully considered works of his Baroque period, the etching of *Christ healing the sick*, known as the 'Hundred Guilder Print' [148].

Christ healing the sick is not dated, and there are relatively few drawings for it. No doubt he worked at it for several years, and the internal evidence, including the drawings, suggests a period between 1642 and 1646. These were the years when Rembrandt was most closely associated with the Mennonites. He never became a signed-on member of the sect, but I think its doctrine had a considerable influence on him. The Mennonites believed in forgiveness, humility and poverty. They had no hierarchy, but accepted the leadership of honest men. In some

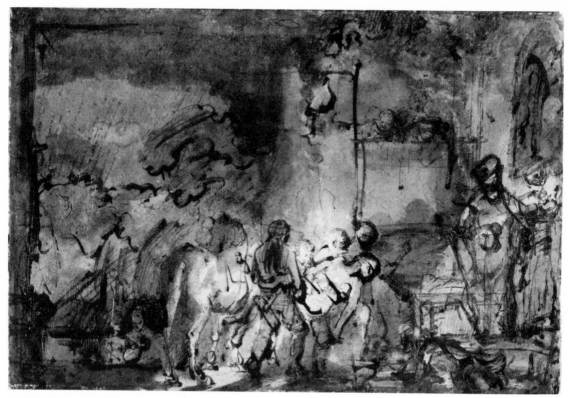

149 *The Good Samaritan. Drawing. Museum Boymans-van Beuningen, Rotterdam*

ways they resembled the Quakers. In the middle of the 16th century they had suffered persecution, but by Rembrandt's time they were accepted, and had among their members the poet Vondel and the great landscape-painter Ruisdael.

I have mentioned the Mennonites at this point because from about 1640 onwards all Rembrandt's illustrations of the Bible could be interpreted as reflecting to some extent their beliefs; and the first great example of this is the etching of *Christ healing the sick*. The print takes its point of departure from the lines in the Gospel of St Mark: 'At even when the sun did set they brought unto Him all that were diseased and them that were possessed with devils, and all the city was gathered together at the door. And He healed many that were sick of divers diseases.' The longer we look at this most famous of all etchings the more we marvel at the observation and the imaginative sympathy which has gone into each figure. The 'Hundred Guilder Print' has an unbroken flow of movement and a perfect unity of atmosphere; and it achieves effects of contrast without the exaggerated use of silhouettes which gave a slightly artificial look to some of his earlier compositions. The whole transition from dark to light has a wonderfully moving quality, and expresses an idea from the depths of Rembrandt's

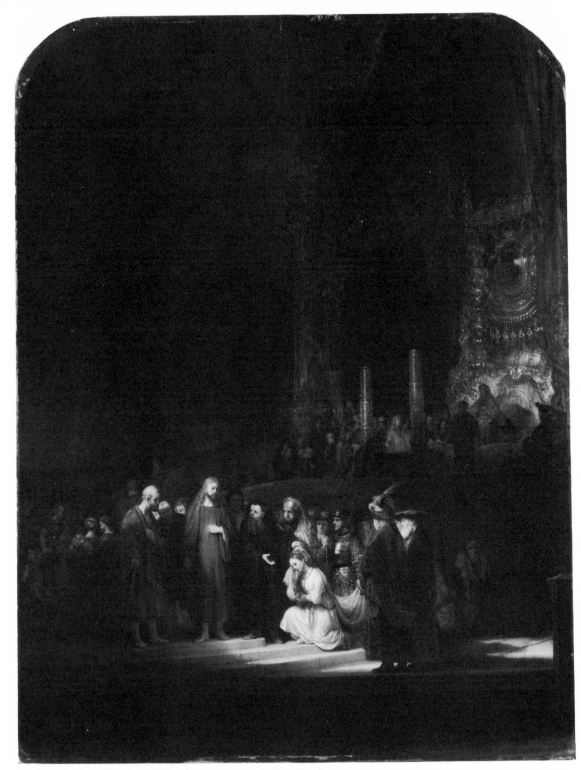

150 *Christ and the woman taken in adultery. National Gallery, London*

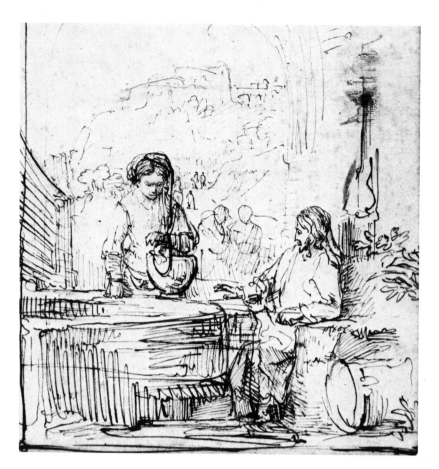

151 *Christ and the woman of Samaria. Drawing. Barber Institute of Fine Arts, University of Birmingham*

imagination – the idea expressed in words by his contemporary, the philosopher Pascal, when he said, 'If there were no darkness man could not be aware of his corruption; and if there were no light man could not hope for a remedy.' Men and women stream out of a cavernous archway seeming, like the prisoners in *Fidelio*, almost blinded by the sudden light. One of them is on a wheelbarrow; a man points to him with a gesture inspired by St Matthew in Leonardo's *Last Supper*; at Christ's feet is a dropsical woman lying on a bier, and above her an old crone, terribly emaciated, raises her hands in supplication. Behind them in the archway is a camel, which seems inappropriate until we remember Christ's words, 'It is easier for a camel to pass through the eye of a needle than for a rich man to enter the Kingdom of Heaven': an example of the wealth of allusion in all Rembrandt's compositions. The figure of Christ (and once more there is a memory of *The Last Supper*), going as far in sentiment as is possible without sentimentality, is a perfect amalgam of human and divine. His raised hand exerts a beatific effect on us through the extraordinary beauty with which it is drawn. On a kind of

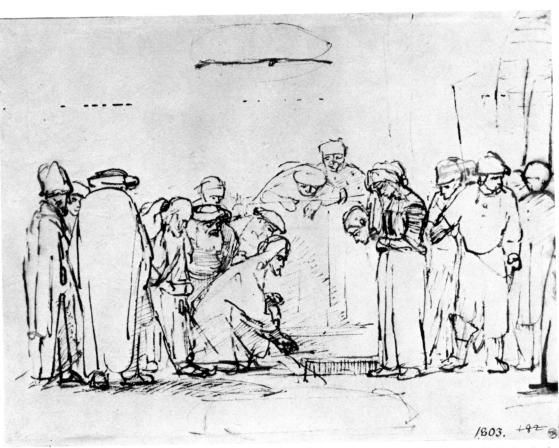

1803.

rostrum to the left (a favourite device of Rembrandt's, and perhaps derived from his love of the theatre) are the spectators, some puzzled and impressed, others contemptuous and defensively hostile.

The 'Hundred Guilder Print' leads me on to another element in the Bible that had a special appeal to Rembrandt: pity, forgiveness, all that is meant by the word 'compassion', which occurs frequently in the Authorised Version, but has now, alas, been overworked. He looks for those moments when love leads to forgiveness. One of the finest of his earlier pictures – certainly the most beautiful in colour – is *David's Farewell to Jonathan* in the Hermitage. The classic example of such compassion, where the word is actually used in the Authorised Version, is the story of the Good Samaritan. The young rebel has made it the subject of his earliest carefully thought out etchings. Fifteen years later he returned to the subject in two magnificent drawings, one of which, in Rotterdam [149], seems to me almost the greatest of all Rembrandt's drawings. They were surely intended as the prelude to a picture, but for some reason it was never painted by Rembrandt himself but left to an

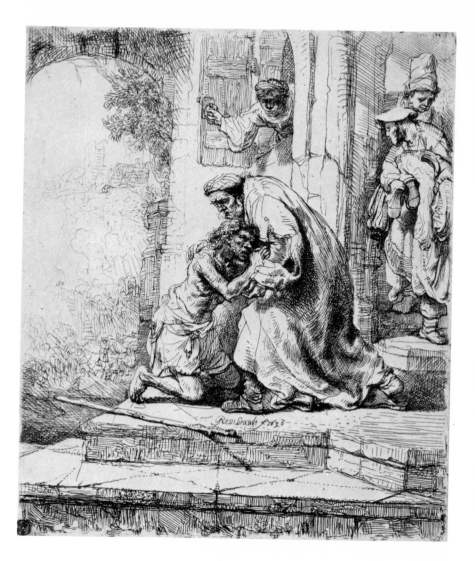

unknown pupil who executed the lifeless picture in the Louvre. Perhaps, as sometimes happens, Rembrandt had put into the drawing a warmth which even he could not recapture.

He had a special sympathy for unfortunate or persecuted women. From the Old Testament he takes the story of the dismissal of Hagar, and it inspires several of his most moving drawings. In the New Testament he returns again and again to the story of the Woman taken in Adultery. A picture in the National Gallery, London [150] dated 1644 depicts the beginning of the episode, where the woman kneels before Christ in the Temple: a small white figure (with exquisite blue satin slippers) isolated in a pool of light. Behind her is the magnificence of the Temple, where some formal display of penitence is taking place

before the High Priest. This is one of the most carefully considered of Rembrandt's pictures of the early 1640s, and some of the details suggest that, in Rembrandt's own words, it had lain long under his hand. In later drawings he sets her in a group as elaborate and articulate as those of the great Italians of the 16th century. Later still he chooses the more mysterious moment in which Christ twice kneels on the ground and writes something (we are not told what) in the dust [152]. It is one of those incidents in the Gospel of St John that by their very strangeness make one believe that parts of it were written by an eyewitness. The drawing is in Rembrandt's bare, classical style – the style of Homer reciting his verses – and the figures are arranged like a frieze, parallel with the picture plane. It is Rembrandt at his most severe and most personal; and yet the composition is based on an engraving by the Elder Brueghel and a picture by Jacopo Bassano.

The woman of Samaria had long been a favourite in art because of the well, Jacob's well, which plays an important part in the story, and provided a painter with a solid centre for his composition. But she was less sympathetic to Rembrandt, because she first of all argued with Our Lord, and then lied to him; and all this is subtly conveyed in a drawing in Birmingham [151] and two beautiful pictures in New York and Berlin. A stupid, obstinate woman, and in one of Rembrandt's etchings

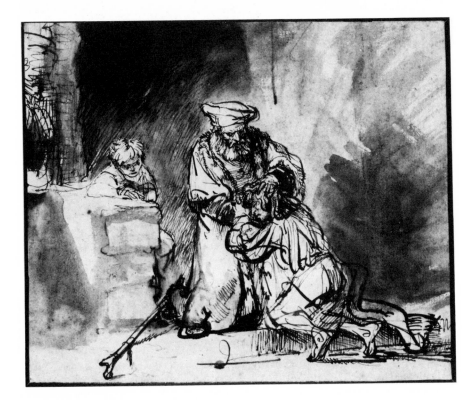

154 *The return of the Prodigal Son. Drawing. Teylers Stichting, Haarlem*

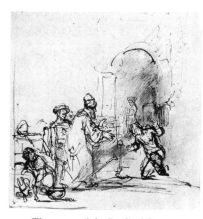

155 *The return of the Prodigal Son.*
Drawing. Museum Boymans-van
Beuningen, Rotterdam

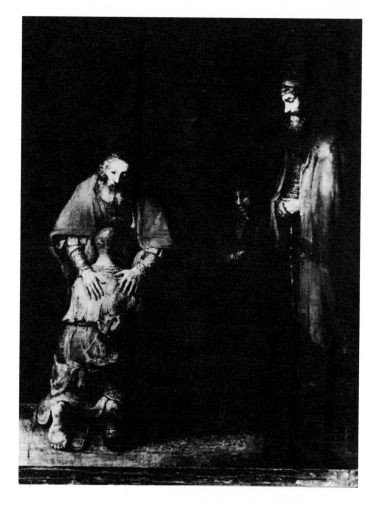

156 *The return of the Prodigal Son.*
Hermitage, Leningrad

remarkably self-satisfied, but she drew from Christ the words: 'God is a spirit, and they that worship Him must worship Him in spirit and in truth'. And she returned to her village saying, 'Is not this the Christ?'

The last, and greatest, of these themes of compassion is the story of the Prodigal Son. He treated it many times. There is the etching dated 1636 [153] inspired by a woodcut by Martin de Vos in which the son has clearly sunk to the lower depths, and the father's forgiveness, his kind old head above the brutalised visage of his son, is almost unbearably moving. Then there is a drawing of about the same date, not I think connected with the etching, in which the son is a more credible figure [154]. Another drawing shows the agitation caused by the son's sudden appearance [155], and yet another the

son sharing the pig's meal.

Finally there is a picture which those who have seen the original in Leningrad may be forgiven for claiming as the greatest picture ever painted [156]. Putting aside superlatives, we may agree that the gesture with which the father puts his hands on his son's shoulders, while his kneeling son presses his head to his father's heart, has an archetypal grandeur and pathos, like some great religious image of the Early Middle Ages. And the way in which they are isolated from the spectators, who watch them as if they were on a railway platform, from which the train has just departed, is one of those strokes of genius that take the words from our lips. How far away are the heaving and grimacing of the early dramas – *Christ before Pilate* or the *Blinding of Samson*! Has any other great artist or poet achieved, through struggle, so simple and accessible an end to his spiritual pilgrimage? For, unlike Milton's *Samson Agonistes* or Beethoven's last quartets, this is not an obscure work; it springs from very deep sources, but affects us immediately.

157 *Christ preaching the Forgiveness of Sins. Etching*

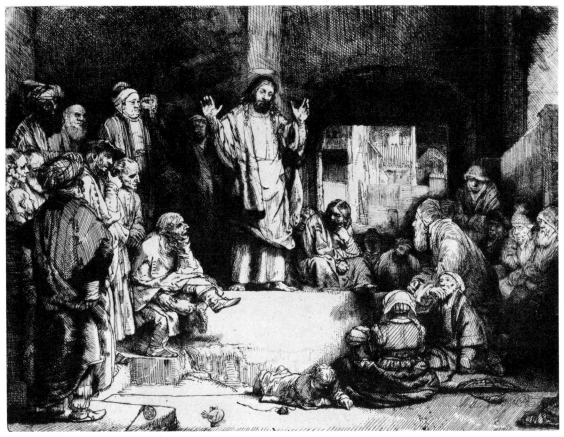

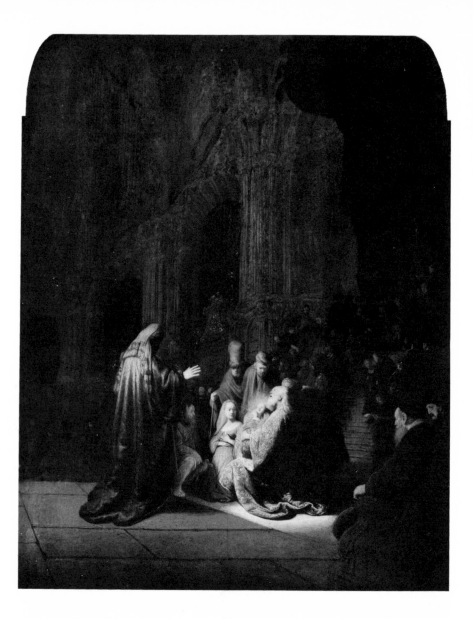

The theme of forgiveness meant so much to Rembrandt that one of his masterpieces is a subject not recorded in the Gospels – *Christ Preaching the Forgiveness of Sins* [157]. This may properly be called a Mennonite theme, although in fact the only other example known to me is in a series of Catholic images by a Flemish painter named Martin de Vos. It is fascinating to compare the artificial poses in this mannerist concoction with the absolute truth of the Rembrandt. Everything seems to have the simplicity of a personal experience; and yet when we study the origins of the composition, we find it is rooted in the central tradition of European painting. The head and gesture of Christ go back

to Raphael's *Disputa*, and the relationship of the preacher to his audience was certainly derived from Raphael's cartoon of St Paul at Ephesus. In the Raphael the audience listens to St Paul with the demonstrative attention of actors anxious to justify their places in the cast. Turn back to Rembrandt's etching and how far away we are from this bodily prosperity, this outward-turning energy. Christ's hearers are a mixed lot of ordinary men and women, some thoughtful, some puzzled, some half amused, some concerned only with keeping warm or keeping awake. A child, for whom the subject holds no interest, is drawing in the dust. But this marvellous feat of observation is without the vulgar anarchy of realism. These individuals are united, not only by a hidden mastery of design, but by Rembrandt's all-embracing, all-forgiving love of his fellow men.

Finally we can say that those episodes in the New Testament to which Rembrandt returned most often were the birth, childhood and Passion of Christ. I have already mentioned the most beautifully human of Nativities, that in the National Gallery, London [87], but said nothing of the marvellous motive of the empty saddle which hangs over the group like a faceless heathen god. Was Rembrandt conscious of this Miltonic invention? Or was it for once a gift from his unconscious mind?

159 *(a) The circumcision of Christ (b) Christ among the Doctors (c) The Flight into Egypt (d) Christ and his parents returning from the Temple. Etchings*

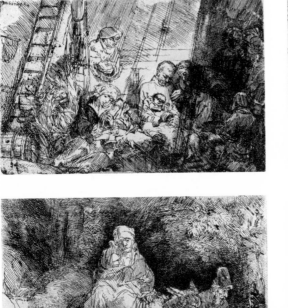

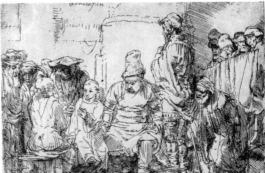

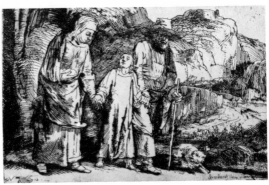

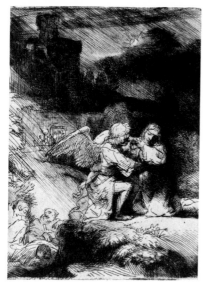

The first of his great temple interiors is the *Presentation in the Temple* in the Mauritshuis dated 1631, in which the isolation of the figures in a pool of light anticipates the *Woman taken in Adultery* by thirteen years [158]. If it was painted in Leyden it suggests how much of Rembrandt's true self was lost for a time after his first triumphant success in Amsterdam.

Dozens of drawings depict the Holy Family, Joseph always much in evidence. Most of them date from the happy years, after 1644, but ten years later he did a series of lightly etched plates [159] that seem to have been thought of as a sequence of the childhood of Christ: the *Circumcision*, the *Flight into Egypt*, the *Virgin and Child with the Cat*, *Christ among the Doctors*, and *Christ and His Parents Returning from the Temple*: 'but His mother kept all these things in her heart'. These etchings have the lyrical simplicity of Berlioz's *L'Enfance du Christ*. It is typical of Rembrandt that he should have taken a particular interest in the subject of Christ among the doctors, and in addition to the etching did several drawings, in which Christ is considerably younger and more combative. One of them is a masterly composition,

160 *The Agony in the Garden. Etching*

161 *The Agony in the Garden. Drawing. Kunsthalle, Hamburg*

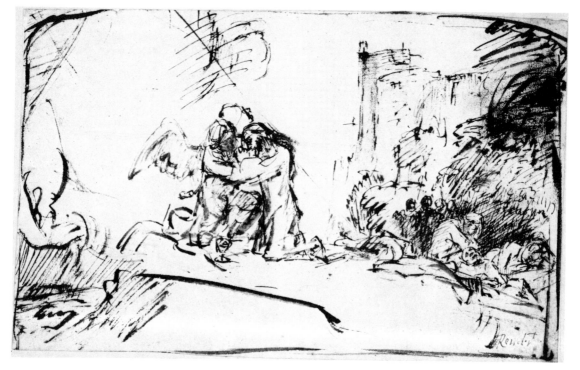

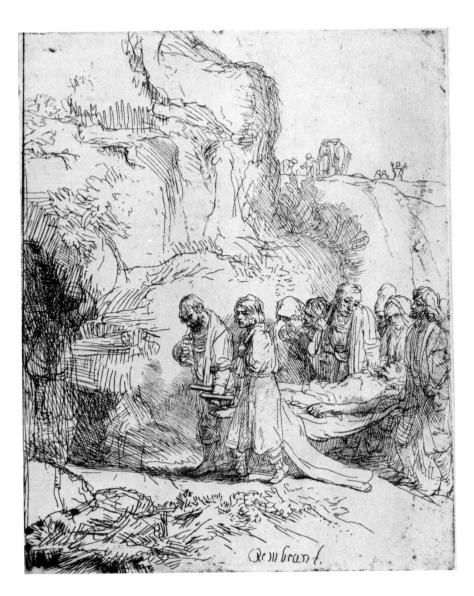

162 *The Entombment.*
Etching

making full use of Florentine perspective; but the gentle, rustic spirit of the etching is more persuasive.

As for the Passion of Christ: it was the subject of that first commission from Huyghens which brought his fame; and he continued to draw, paint and etch various incidents throughout his life. Among his most personal drawings and etchings are those representing the Agony in the Garden. In this drawing [161] Rembrandt has put into the strokes of a reed pen an almost unbearable emotion: it is one of several studies which were simplified into the finality of an etching of 1657 [160] – one of the most economically perfect of all Rembrandt's works. It is almost equalled by a small etching of the Entombment done at the same time,

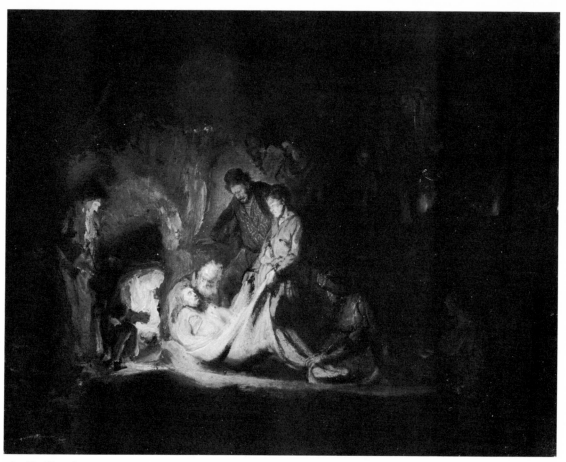

163 *The Entombment.*
Hunterian Collection,
University of Glasgow

which has the simplicity of a poor family taking their father to a pauper's grave – and, in fact, the leading figure carrying the stretcher is clearly a portrait of Titus [162]. The idea of the Entombment, when the perfect man seemed finally lost to the world of men, evidently moved him deeply, for it inspired far the most poignant episode of the early Huyghens series, and is the subject of many later pictures and drawings, of which a study in Glasgow, like the etching of *The Agony in the Garden*, is a sort of summing up [163].

I have left the Crucifixion to the end, because it is the subject of one of Rembrandt's works that leave us with no more to say and no wish to look any further, the etching known as *The Three Crosses* [166]. He had been drawing the Crucifixion all his life, and we may consider two contrasting examples, partly because they tell us so much about the evolution of his style: first a relatively early drawing [165] in which the onlookers are done in Rembrandt's cursive baroque style with large sweeps of the pen, but the figure of Christ is more deliberately drawn,

and obviously inspired by a piece of Late Gothic
sculpture, as if Rembrandt felt that the smooth-fleshed
figure of a baroque Christ could not be made sufficiently
tragic. The other drawing, about twenty years later, is in
Rembrandt's economical, classic style, with forms
reduced to rectangles [164]. It was probably done a little
later than the first impression of the great etching, and
the figure of Christ is very similar.

In the first impression he has conceived the
Crucifixion as the break-up of a world. The crucified
Christ is isolated, suffering but triumphant. On the
right, below the figure of the repentant thief, Christ's
followers are in despair. To the left, are the indifferent
soldiers, literally faceless executors of the law, all except
the centurion who saw what was done and glorified God,
and 'all the people that came together to the sight smote
their breasts and returned'. Almost ten years later he
reworked the plate even more drastically than he had

164 *Crucifixion. Drawing*

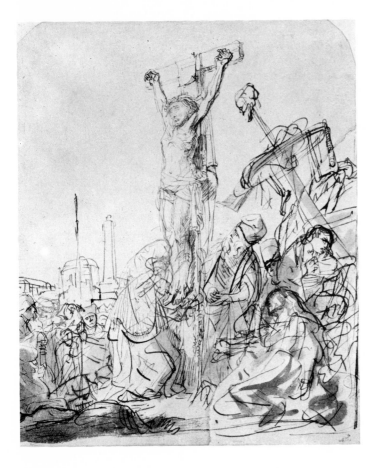

165 *Crucifixion. Drawing. Staatliche
Museen Preussischer Kulturbesitz, Berlin
Kupferstichkabinett*

166 *The Three Crosses. Etching. Early state*

reworked the *Christ Presented to the People*, and under rather the same impulse [167]. A dramatic record is made into a mystic experience – 'There was darkness over the face of the land'. Like a curtain that is being drawn, it blots out the penitent thief, and obscures Christ's followers, who are nevertheless discernible in attitudes even more piteous than in the earlier state. But the changes to the left of the Cross are far more profound. Gone is the kneeling centurion, the worldly, Raphaelesque element in the earlier design, and gone the indifferent soldiers. And in their place is a man on horseback whose weird profile is obviously derived from Pisanello's medal of Gian Francesco Gonzaga.

By what stroke of inspiration did Rembrandt see this bizarre figure as adding something to the mystery of a darkened world? Did he feel in Pisanello's perfectly calculated profile a detachment which he could use as a symbol of loneliness? Did he feel, as in the Claudius Civilis, that

some touch of the grotesque would heighten our feeling of the incomprehensible? The enormous hat seems to have grown in the night like a giant toadstool. It belongs to the non-human order; and yet the chinless head below it is human and touching in its feeling of resignation; and to give it greater poignancy, Rembrandt has adumbrated behind this passive, unclassical image one of the great symbols of classical energy, the horse-tamer of the Quirinal. Once more he makes use of allusions and analogies which cannot be accounted for by coincidence, and which argue a deep understanding of the mechanism of the unconscious.

Just as critics of Shakespeare, following Milton's lead, used to speak of him as 'warbling his native woodnotes wild', and ignored the counterpoint of classical allusion in *King Lear*, so Rembrandt scholars for long pretended that Rembrandt addressed us with artless simplicity;

perhaps because the myth of the inspired simpleton is the only way in which we can preserve our *amour propre*, by shielding ourselves from the realisation that genius involves mental faculties of an altogether different order from our own.

So much of Rembrandt has had to be left out of this introductory book. But, in spite of all the omissions, I hope I have been able to convey something of the immense seriousness and feeling of personal responsibility with which Rembrandt contemplated the moral and spiritual condition of man. To him the formalised gestures and symbols which make up so much of religious art were evasions of that responsibility. He was not supported by dogma, like Titian, or by Neoplatonic philosophy, like Michelangelo. He was alone with his experience of human life, which he had to lift on to a spiritual plane without any sacrifice of truth, and with no other guidance than the words of the Bible.

List of Illustrations

Index